Harlow and Sage
(and Indiana)

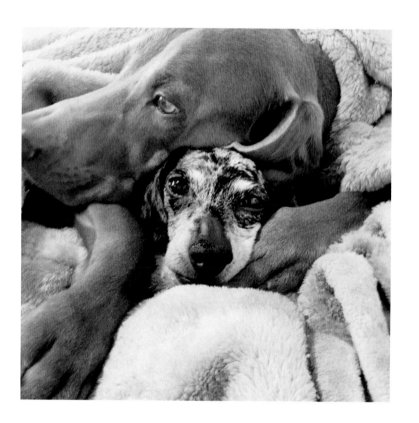

G. P. PUTNAM'S SONS
a member of Penguin Group (USA)
New York

HARLOW
and SAGE

(and Indiana)

~~~~~~~~~~

### BRITTNI VEGA

FOR OUR BEST FRIEND, SAGE

This is a true story. Well, some of it. Most of it.

Hi there. My name is Harlow Morgan Sage. I am a Miniature Dachshund.*

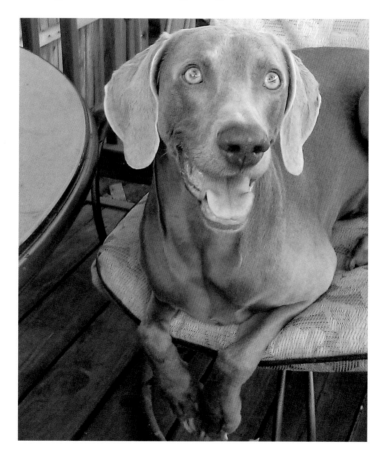

I am a middle child. I know what you are thinking, Oh dear, she must have middle child syndrome. But don't worry, I don't. I am not your typical middle child.

*Unlike Indiana and Sage, Harlow is actually a Weimaraner.
We just don't have the heart to break it to her.

For the first five years of my life, I was the youngest, the baby in the family, the golden child.

And . . . I was Sage's little sister.

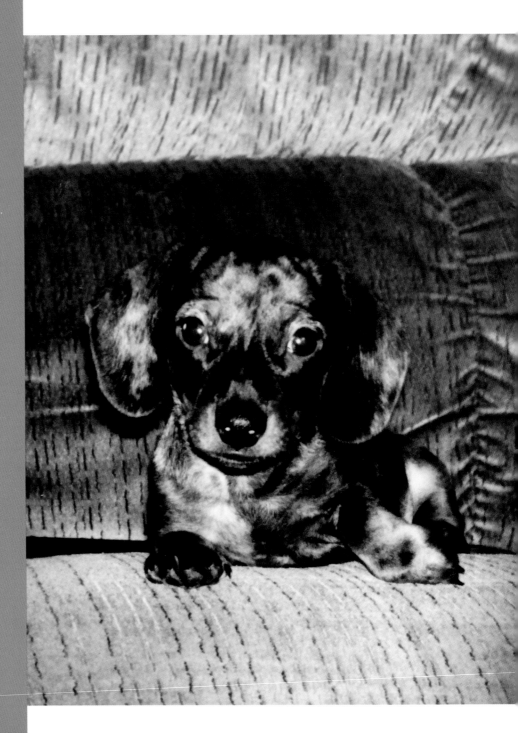

Sage became an orphan in the year 2000, when she was just a few months old. Her birth parents were facing difficult times and could not keep her. Luckily for Sage, on the other side of town there was a young girl in desperate need of a best friend, and so Sage packed up her tiny suitcase, her tiny pillow, and her tiny toothbrush and moved in with the young girl.

Sage settled in comfortably with her new family and became quite attached to the young girl. The two of them were the best of friends and they did everything together: went out on their first dates, got their driver's licenses, graduated from high school, and started college.

Eventually the young girl grew into a young woman and met a nice young man.

He quickly became her very best friend, and not long after . . . they were married.

They started their new life together, the young woman, the young man, and Sage.

As much as Sage liked her new family, she was starting to feel like a third wheel, and both of her parents could tell.

And so the two of them set out to find the perfect sidekick for their beloved Sage.

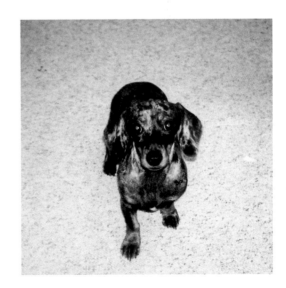

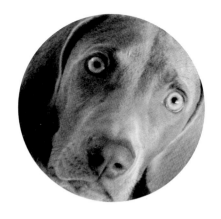

"You are going to love your new sister, Harlow!" Papa said to me as we pulled into the driveway. It was a warm, sunny day in March 2008.

Sage was waiting for us at the front door as we walked into the house. Papa set me down in front of her. She sniffed my nose, my ears, my derriere. She stared at me for a very long time before asking, "What is your favorite Meryl Streep movie?"

At the time, I had never heard of a Meryl Streep before. I was just a tiny infant. I didn't know much about anything . . . yet.

"All of them," I finally replied.

"Good," she said. "My name is Sage. I like your ears. They are big. You must be a good listener."

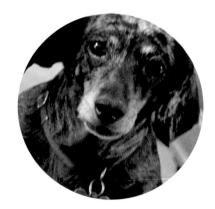

From that day forward, Sage and I were inseparable. She was everything a dog (or human, even) could ask for in a best friend. She shared her treats. She let me bite her ears when we played. She even let me sit beside her in the front seat on car rides.

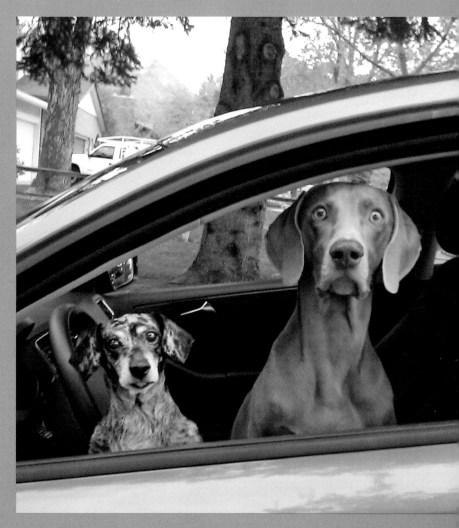

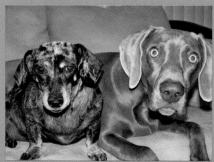

I had never known anyone in my whole life who was as easy to get along with as Sage. We spent hours and hours on the sofa together talking about everything and nothing at all.

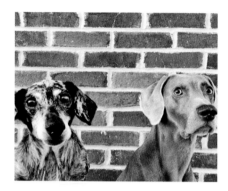

Sage taught me all about the world and answered almost all of my questions. There was so much that I just didn't understand.

"Why do we sneeze? Where did all of the dinosaurs go? Were 'The Beatles' actual insects or were they humans?"

Sage was very smart and a truly interesting critter. There was no question that she didn't have the answer to. I often wondered how she knew so much.

"How come you know so much, Sage?" I asked.

"I have been around for a long time," she told me. "I read a lot."

"Who taught you how to read?" I asked.

"I don't know. Maybe I was just born that way. Quit asking so many questions," she snapped.

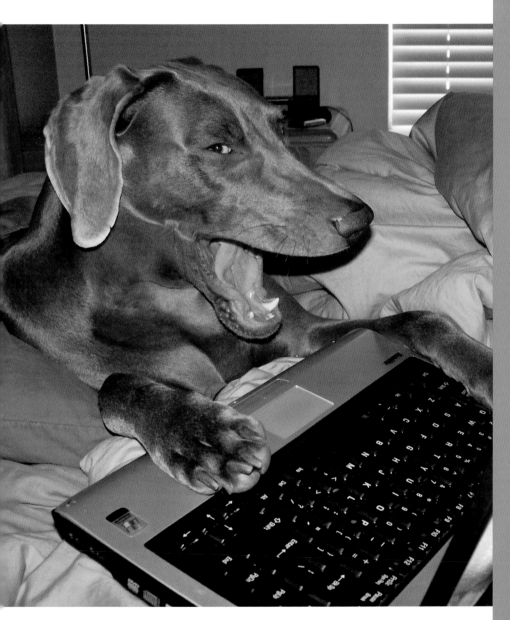

Sage taught me how to read. How to dumpster-dive. And how to use a computer.

"It is like a whole world of information right at your ~~finger~~ paw prints!" she explained to me while showing me how to operate the keyboard.

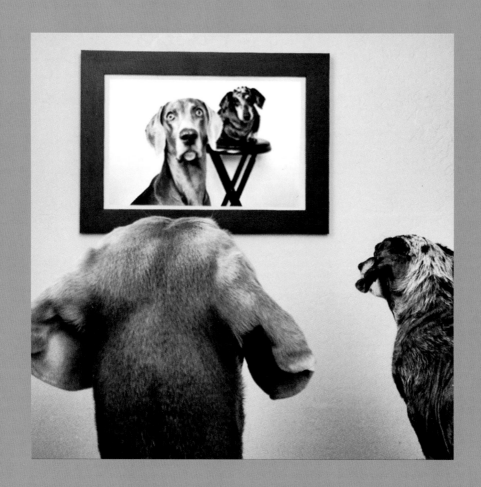

# ADOPTED

On my first birthday, Sage decided to tell me that I was adopted. As you can imagine, I. WAS. SHOCKED.

I struggled at first to grasp that we weren't real sisters. I had never noticed a difference in our appearance. We were both short in height. Dark features. Long noses. If Sage wasn't eight years my senior, someone may have mistaken us for twins.

"It doesn't matter, Harlow!" Sage said. "Being adopted is a beautiful thing! It makes you even more special."

I believed her.

Our parents had never treated me any different. I wasn't allowed in the kitchen when they cooked, but I think that was due to my chocolate allergy, not the fact that I was adopted. I was also not allowed to sit on the leather sofa in the formal living room, not because I was adopted but most likely because it was uncomfortable and they didn't want me to hurt my back.

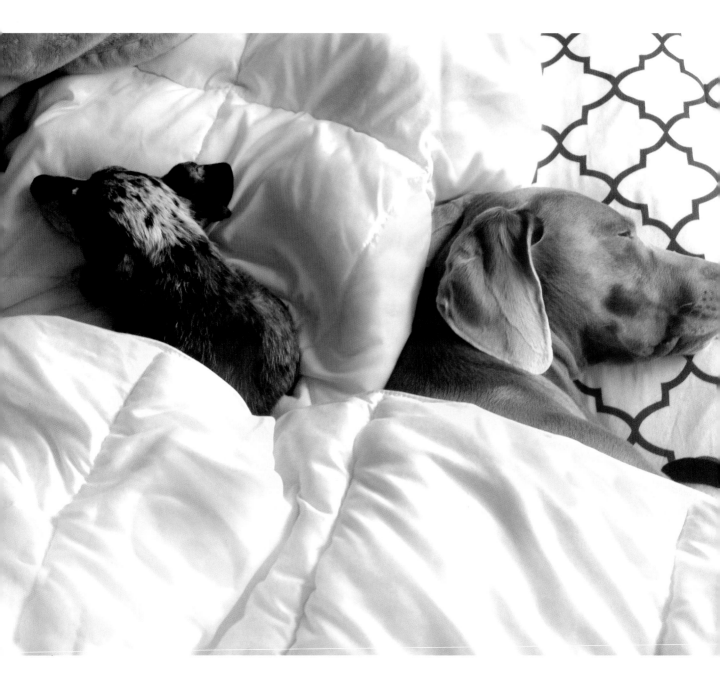

Like most siblings, Sage and I shared a bedroom. We had two twin beds, but eventually Sage's bed turned into my bed due to my greatest fear in life: thunder.

Sometime during my first year on planet Earth, there was a thunderstorm. I did everything I could to be brave but it was just too much. I couldn't handle the noise. I couldn't find where it was coming from!

"Harlow!" Sage whispered. "Come out from underneath the bed! You are acting like an animal!" I did not come out. No way was I going out to face that noise. If the thunder was going to get me, it would need to find me first.

Unable to coax me out, Sage did something that I will never forget: she joined me under there. She brought all of her blankets and we slept, cuddled up, underneath my bed. From that night on, that is how we slept. Not under a bed, of course—but together, cuddled up.

Sage may have been just a tiny bit smaller than me but I never questioned her ability to protect me from scary things like thunder, ice cream trucks, or the vacuum cleaner. She was the best big sister in the whole world.

# HUNTIN' DOG

Sage wasn't much for playing outside but she did love to watch birds.

I would play with my toys on the grass and Sage would sit perched on a bench or in a tree, bird-watching.

"That right there is a ruby-throated hummingbird," Sage would tell me. "And over there is a northern mockingbird."

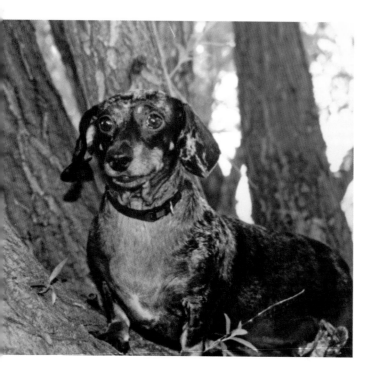

"Cool," I would reply, and go back to shredding some rubber.

Sage watched birds just for the love of the game. She was not some sort of predator. I like birds too. Whenever they land near me, I try to sneak up and play with them. They always fly away before I have an opportunity to introduce myself.

"What are you going to do if you actually catch one?" Sage asked. "Smother it in kisses?"

People always assumed that I was a bird dog. I wasn't entirely sure what that meant. "That right there is a beautiful bird dog you got!" or "That's one good-lookin' huntin' dog!" strangers would say to my papa when they would see us at the Home Depot.

My papa would just look down at me and smile. "If they only knew." He would laugh. My papa and I were not hunters. The only thing the two of us had ever hunted were car keys because his always seemed to be lost.

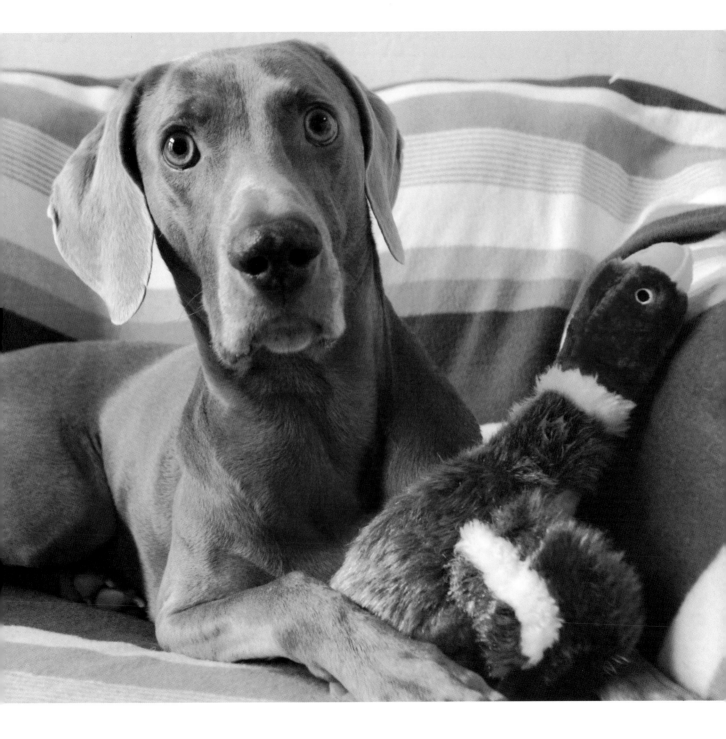

# MERYL-ING: PART I

When waiting for humans to return home from work eight hours a day, five days a week, we dogs have a lot of time on our ~~hands~~ paws.

Every day after my parents left the house Sage and I would look through the newspaper, watch funny cat videos online (my computer skills had become impeccable!), and have a Meryl-marathon.

Sage had spent much of her life admiring the work of legendary film actress Meryl Streep. When I came into the picture, Meryl became someone we could both look up to and enjoy together. And boy was she something!

Sage and I managed to bond over almost all of Meryl's movies. She taught us how to cook in *Julie & Julia*. She taught us how to dance in *Mamma Mia!* We learned the importance of making some of life's most difficult choices from *Sophie's Choice* and *Kramer vs. Kramer*. She even taught us that it is okay to act a little bit mean and scary as long as you look fabulous while doing it in *The Devil Wears Prada*.

Those were some of my most favorite times. Just the two of us. And Meryl Streep.

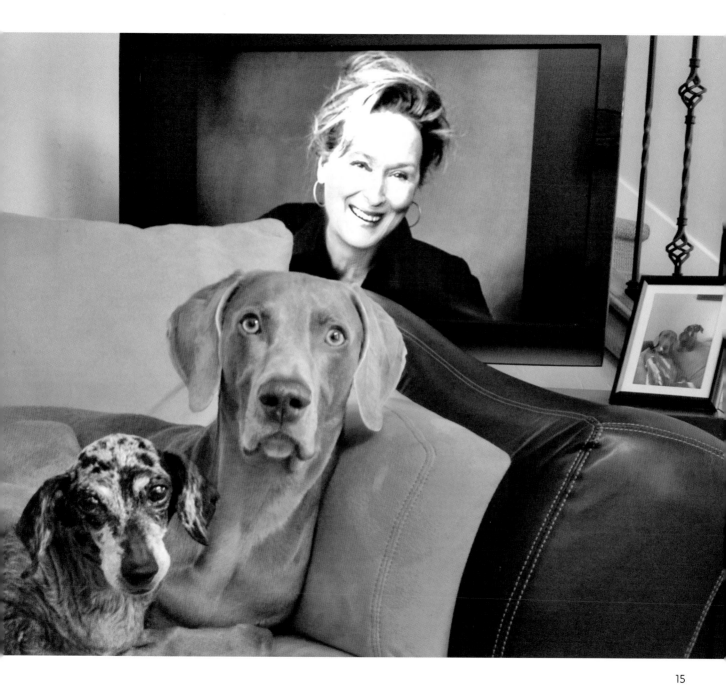

# GRANDPARENTS

We have these adorable little ladies in our lives who come and visit us when our parents are working. Sometimes we go to their houses. They give us treats. (The good kind of treats that my parents aren't nice enough to let us eat.) They let us up on their furniture so that we can nap with them.

These ladies are called GRANDMOTHERS. They are the most magical creatures you could ever imagine.

My mother is a dear heart but my grandmothers are spectacular angels.

# WE ALSO HAVE A FEW GRANDFATHERS

The grandfathers usually come to our house when they have to save the day. Once, the sink in the bathroom was spraying water all over the ceiling.

"I don't think that is good," Sage had said as we watched it from the hallway. Water was beginning to turn the bathroom into a pond.

When my papa came home from work a few hours later, he set his keys down and took off his shoes. "Where are my two favorite friends?" he happily called from the kitchen. This was his regular routine.

Neither one of us wanted to stop watching the water show that was taking place in the bathroom, so we didn't go and greet him like we normally did.

"Oh no!" he screamed as water sprayed his face. He couldn't get it to stop. The water was rising and now the pond was more like a lake.

"This is so fun!" I told Sage as I splashed around in it.

Not long after, my grandfather showed up with his box of toys. He used them to make the sink stop spraying water. I helped by getting each one out of the box for him. He has the most amazing toys in the entire world. Whenever I get them out of the box, he takes them away from me and says, "No! No! No, Carlos!" (He still doesn't know my name is actually Harlow.)

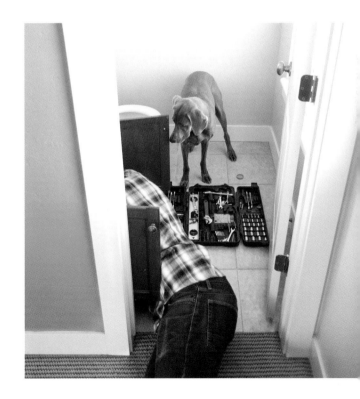

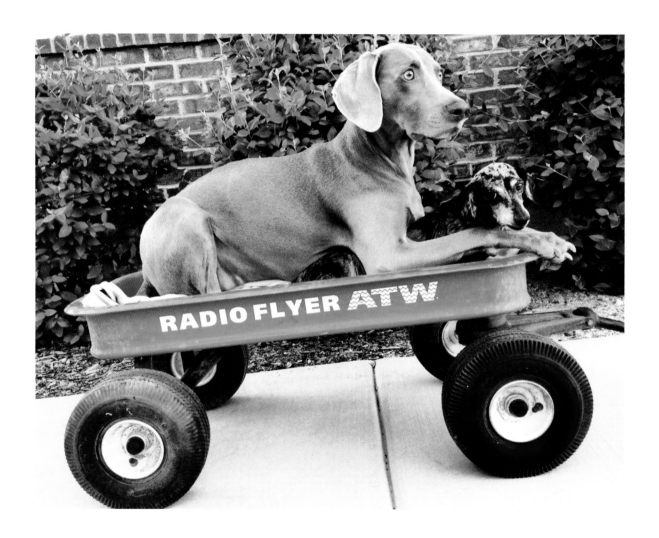

In the early years, Sage was right by my side when we would take our afternoon stroll. Sometimes I even had a difficult time keeping up with her. Those short little legs are faster than you think! As she got older, though, Sage became much less interested in walking. We would leave the house, ready for our evening walk, and she would sit right down on the sidewalk, not budging. Sage opted to be carried or wheeled wherever we went. If we were going on a long walk, our parents would put her in a wagon.

If it was just for a short walk, I would stick her on my back. That was her most favorite place to be.

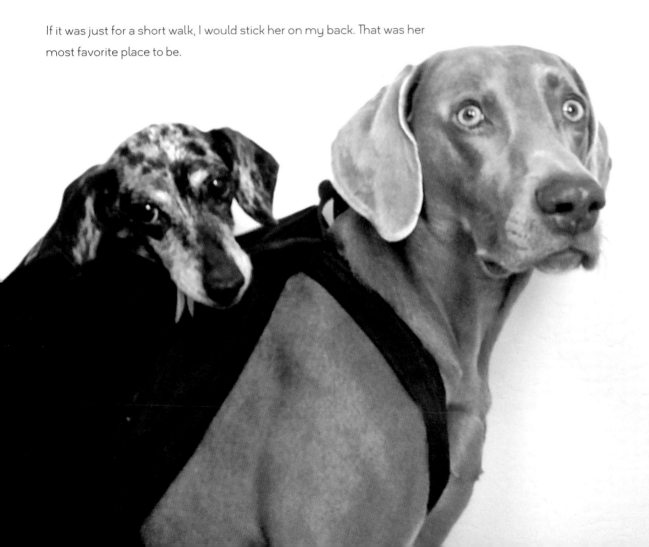

Sage's insistence on not walking made it difficult for us to go on adventures together.

"Who wants to go for a ride?" our mother would ask when it was time to do something exciting. Sage would sit in the corner of the living room, not coming to our parents to get her leash on.

"Okay, Sage," my mother would say. "Do you want to go to Grandma's instead?" Sage would go crazy! Wagging her tail, happy as ever. (Lots of treats and cuddles at that place!)

She would spend the afternoon with our grandmother while I got to go somewhere fun like the dog park or up the canyon.

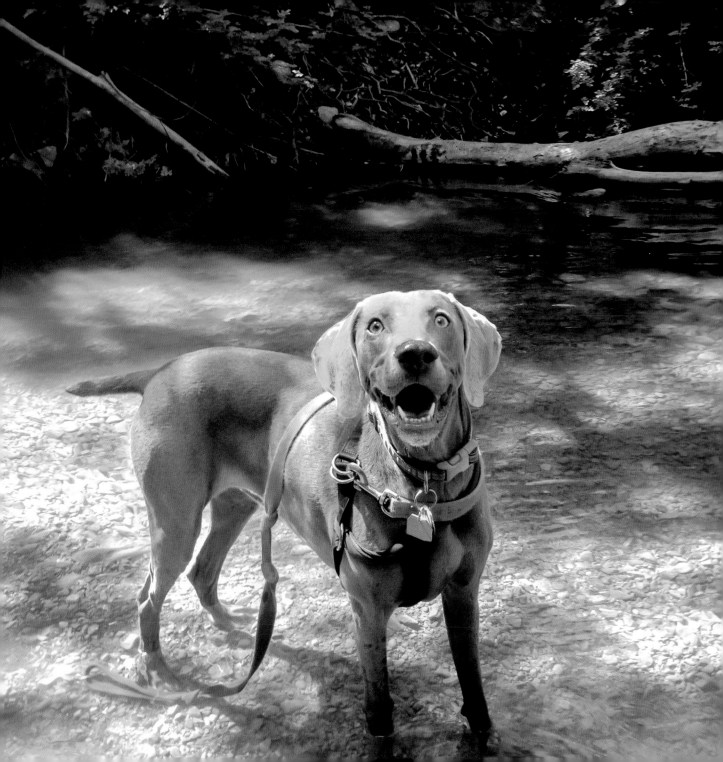

"It's not that I don't want to go," Sage said. "It's just that I would much rather eat treats with Grandma all day in the comfort of her home than go out and get my paws dirty!"

I wanted to believe her but I secretly knew the truth. She was getting old. I understood that she didn't want to own up to it. She was very proud, that Sage!

I acted like nothing was different, but I did start to take her age into consideration. I was a little bit gentler when we played. (I didn't want to break one of her hips.) And I spoke just a little bit louder so she could hear everything I said.

"HOW ABOUT THAT WEATHER TODAY, SAGE?" I yelled at her one morning while we were out on the lawn sniffing for a place to . . . you know.

"Why are you shouting, Harlow? I am standing right here."

# THE HOLIDAYS

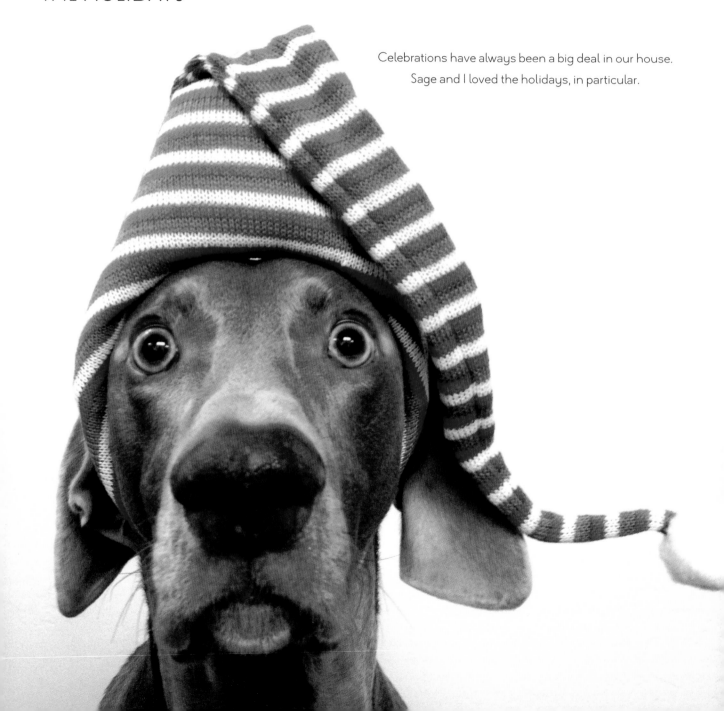

Celebrations have always been a big deal in our house.
Sage and I loved the holidays, in particular.

She especially loved Christmas.

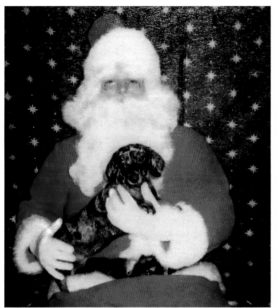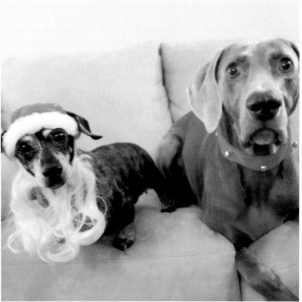

Every year on Christmas morning our parents would sneak down to
the living room and set up all of our presents. We would wait patiently
and then, when it was time, we would run as fast as we could into the
living room and go berserk unwrapping our gifts. Sweaters, squeaky
toys, treats, William Wegman calendars, rollerblades!
Christmas was a fantastic occasion!

"No matter what happens, Harlow, you have to always make sure
that Christmas is the best day of the year," Sage explained.

As much as I like Christmas, Halloween is more my style. They don't call me "Harloween" for nothing! I. Love. To. Dress. Up! And not to ring my own bell or anything, but I can pull off almost any ensemble!

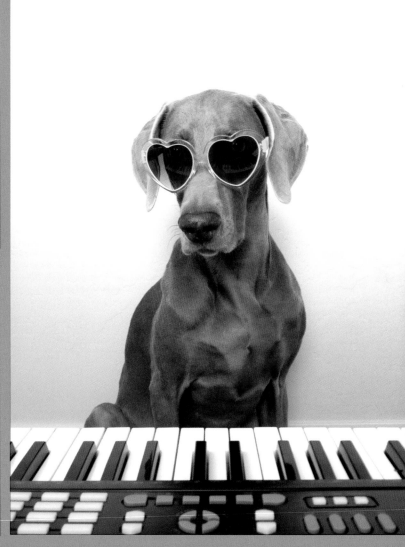

In March 2013, Sage and I celebrated our fifth year together by watching the 85th Annual Academy Awards. Even though our Meryl wasn't nominated, she still did a fantastic job presenting.

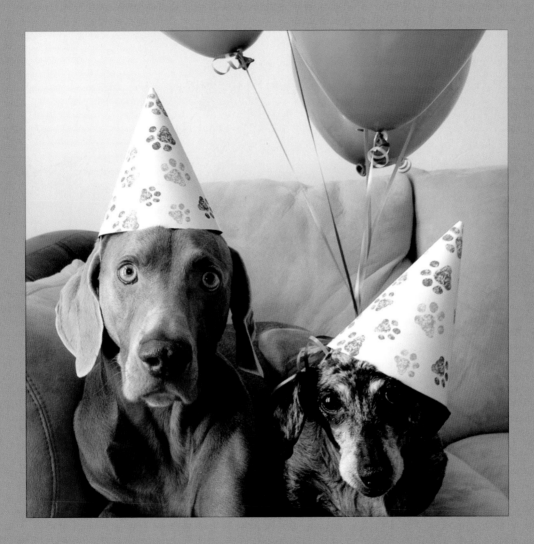

One of my most favorite memories with my very best friend.

Shortly after the Oscars, I began to notice more changes in Sage. She was tired pretty much all the time, she didn't like to eat as much, and she was so forgetful. She would lose her chew toys everywhere we went!

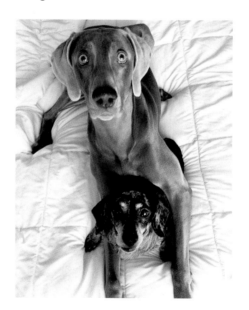

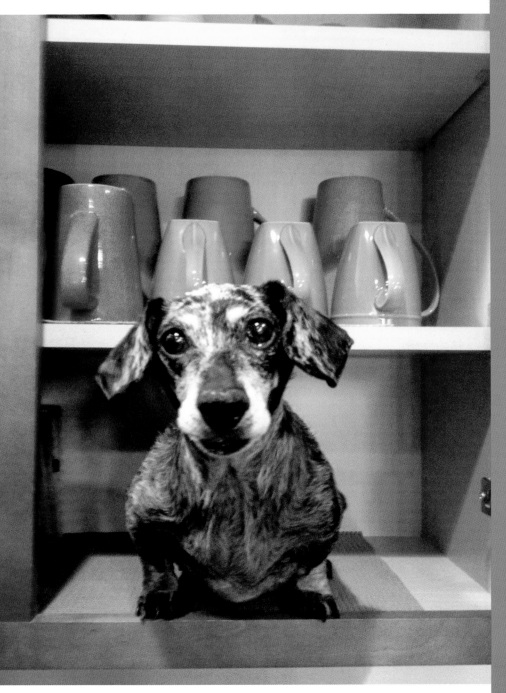

## FOODIE

Sage's lack of appetite was the biggest concern because it was so unlike her.

I love dog food. Kibble mostly. (I know it might not sound that appetizing to you, but I have a sensitive stomach. I think it might be a gluten intolerance.) Sage, on the other hand, could eat anything, and although she was aware of its risks, she loved herself some chocolate.

I remember one time I watched her in a quest to retrieve a ten-pound chocolate Easter bunny from a very high cupboard. She climbed her way to the top, and when she reached her destination she realized that the bunny was no longer there and that she couldn't get back down.

"Oh, Harlow! They are going to take me to the pound when they find me up here, I just know it!" Sage cried.

I didn't know what to do. I paced back and forth on the tile floor for five long hours while Sage was stuck on top of a shelf in the kitchen, until our parents finally came home and got her down.

They weren't mad. Sage never got in trouble. Sometimes I secretly held this against her, but then I also understood how difficult it was to be mad at her.

There was once an incident where I walked in on her chewing the left arm off one of my favorite babies. When I started to whimper, she looked up at me with those big black eyes. My heart turned to mush! My anger disappeared and, just like that, I was no longer upset.

And Sage went back to chewing.

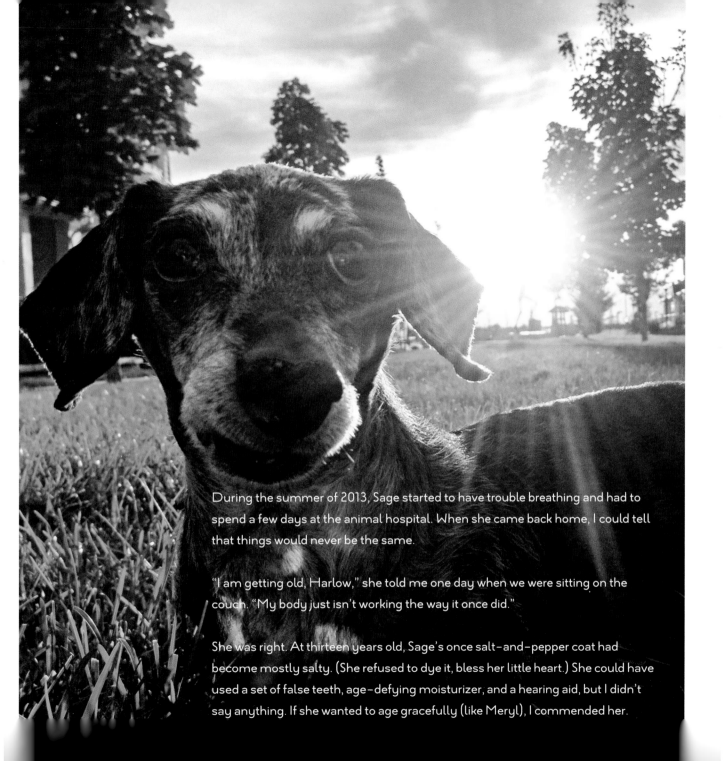

During the summer of 2013, Sage started to have trouble breathing and had to spend a few days at the animal hospital. When she came back home, I could tell that things would never be the same.

"I am getting old, Harlow," she told me one day when we were sitting on the couch. "My body just isn't working the way it once did."

She was right. At thirteen years old, Sage's once salt-and-pepper coat had become mostly salty. (She refused to dye it, bless her little heart.) She could have used a set of false teeth, age-defying moisturizer, and a hearing aid, but I didn't say anything. If she wanted to age gracefully (like Meryl), I commended her.

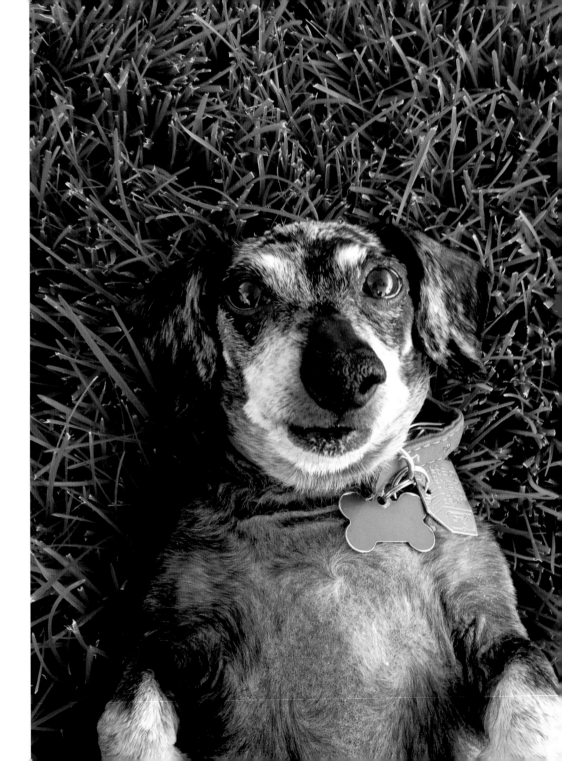

## LOVE BITES

Sage and I spent a
lot of time lounging
around on the grass
in front of our house.
No matter how sick
she was feeling, she
was never too weak
to lie in the grass.

One day I was on the porch looking down at Sage while she sat on the grass. The next thing I knew, a very large dog was running toward her, jaws open, ready to attack. Or maybe play. I have no idea. Either way, it was not going to get to Sage without going through me first.

Now listen, I am by no means a creature of violence. In fact, I hate confrontation. But when it came to protecting my best friend, I was willing to do anything. Before Sage could turn herself around to realize what was happening, the large dog and I were fighting. It was the first scuffle I had ever been in.

My papa and the big dog's papa pried the two of us apart. We were both yelping. I was absolutely terrified. I think the other dog was too.

And then I may have fainted, because the next thing I remember was waking up at the animal hospital.

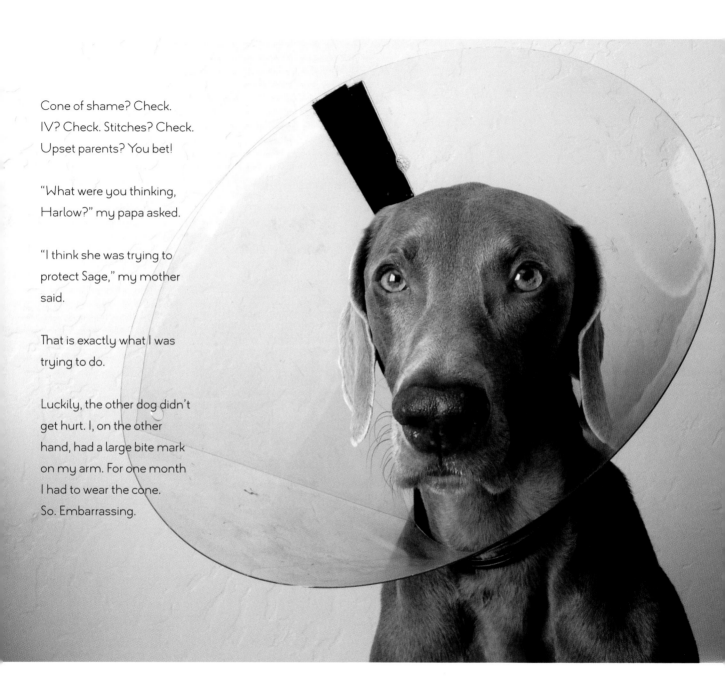

Cone of shame? Check.
IV? Check. Stitches? Check.
Upset parents? You bet!

"What were you thinking,
Harlow?" my papa asked.

"I think she was trying to
protect Sage," my mother
said.

That is exactly what I was
trying to do.

Luckily, the other dog didn't
get hurt. I, on the other
hand, had a large bite mark
on my arm. For one month
I had to wear the cone.
So. Embarrassing.

Sage was a wonderful nurse during this time. She didn't act annoyed when I knocked things over with the cone. She gave me her share of doggy ice cream. She didn't make fun of me for looking like an upside-down lamp shade. She was an absolute gem.

I have a little scar on my shoulder in the place where I was bitten. It is a tiny little reminder of the time I saved my best friend's life.

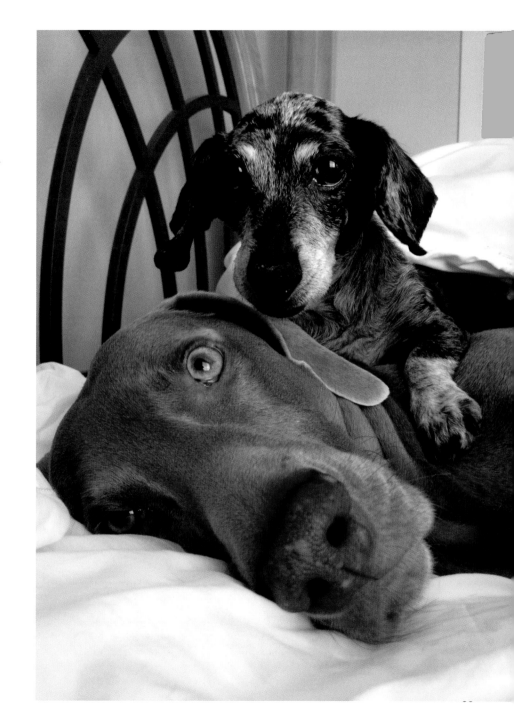

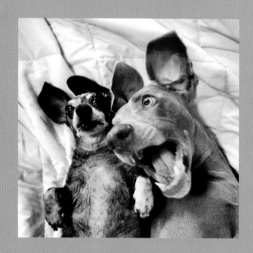

## CLASSIC JOKE MONDAY

In an effort to keep Sage happy and smiling, I added Classic Jokes to our daily routine. Each morning I would wake Sage up with a Classic Joke. She loved it! But I ran out of jokes after two weeks. And so I took some pointers from my favorite daytime TV personality, Ellen DeGeneres, and I started up Classic Joke Monday! It was a real hit. Sage looked forward to it every week.

Q: What do you call a grizzly bear with no teeth?
A: A gummy bear.

Q: How many tickles does it take to make an octopus laugh?
A: Ten-tickles.

Q: How do you plan a party in outer space?
A: You planet.

Q: Why couldn't the bicycle stand up on its own?
A: It was two tired.

Q: Why do ghosts hate going to dances?
A: They have nobody to dance with.

Q: What are the strongest days of the week?
A: Saturday and Sunday. The rest are just weekdays.

Q: Why was the police officer hiding under the sheets?
A: He was undercover.

Q: Why did the bowling pins stop working?
A: They went on strike.

Q: What do you call an alligator wearing a vest?
A: An investigator.

Q: How do spiders communicate?
A: By using the World Wide Web.

Q: What runs around a cemetery but doesn't move?
A: A fence.

Q: What did the digital clock say to the grandfather clock?
A: "Look, Grandpa, no hands!"

Q: Why did the scarecrow get a promotion?
A: He got a promotion because he was outstanding in his field.

Q: What did the pony say when he had a sore throat?
A: "Pardon me, I am just a little hoarse."

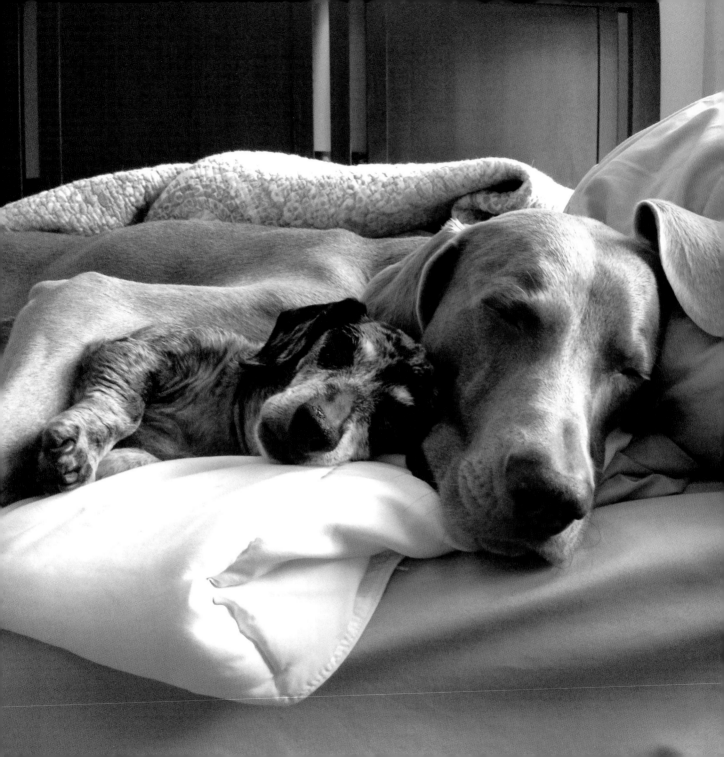

It was clear that Sage's and my time together was running out. She was spending more and more of her days at the animal hospital. I overheard my parents say that her heart was failing . . . whatever that's supposed to mean.

Through it all, Sage did her best to act like her happy old self. She never complained or tried to bother anyone.

When she was home, I did everything I could to make each day special. We spent lots of time relaxing, cuddling, and, of course, Meryl-Movie-Marathoning. (It's a great way to spend a Sunday—you should try it sometime.)

My parents also did everything they could to make sure Sage was comfortable. They made her special food, let her sleep in bed with them at night, and carried her everywhere. Nothing seemed to help, though.

I really couldn't picture my life without Sage. We had spent every single day together. I knew she wasn't happy being so sick but I still wished that she could stay with me forever. She was my very best friend.

"Everything will be just fine, Harlow, you'll see," Sage reminded me. "I will be with you no matter what, even if it's just in your heart."

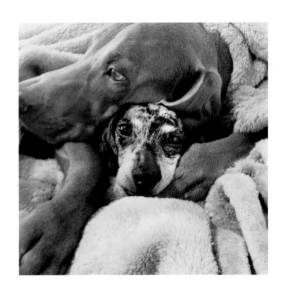

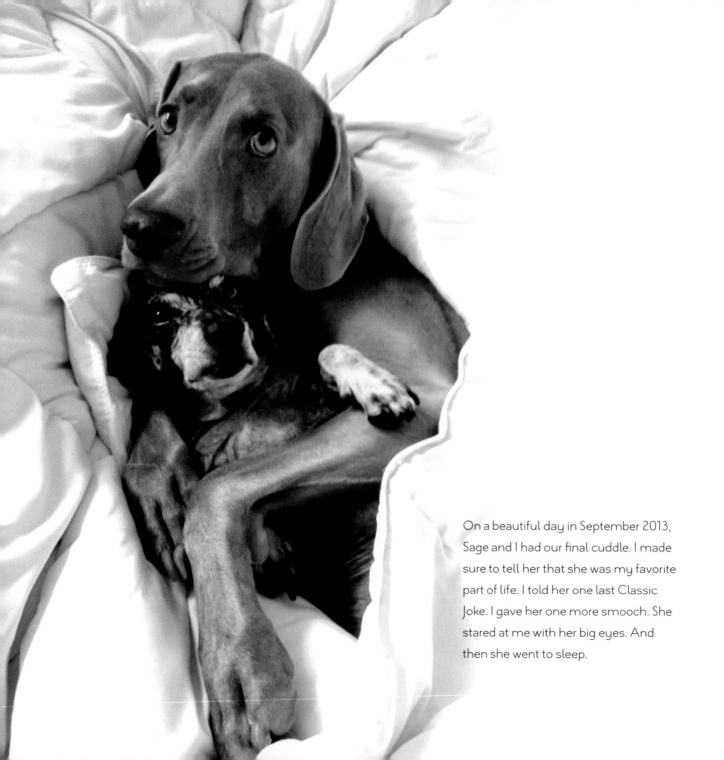

On a beautiful day in September 2013, Sage and I had our final cuddle. I made sure to tell her that she was my favorite part of life. I told her one last Classic Joke. I gave her one more smooch. She stared at me with her big eyes. And then she went to sleep.

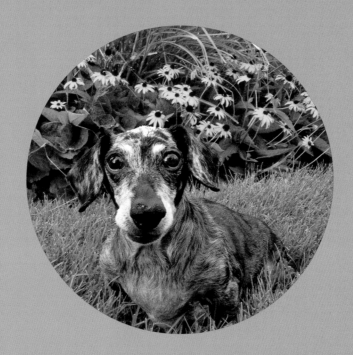

I hope that when she woke up
she was in a place where it is
legal for dogs to eat chocolate.

For the next few days, it was just me.

My parents stayed home from work to be with me,
and the three of us took long walks and I got extra
treats and extra cuddles.

But it wasn't the same. I was lonely. I missed Sage,
and I think my parents could tell, because I remained
an only child for exactly one week more.

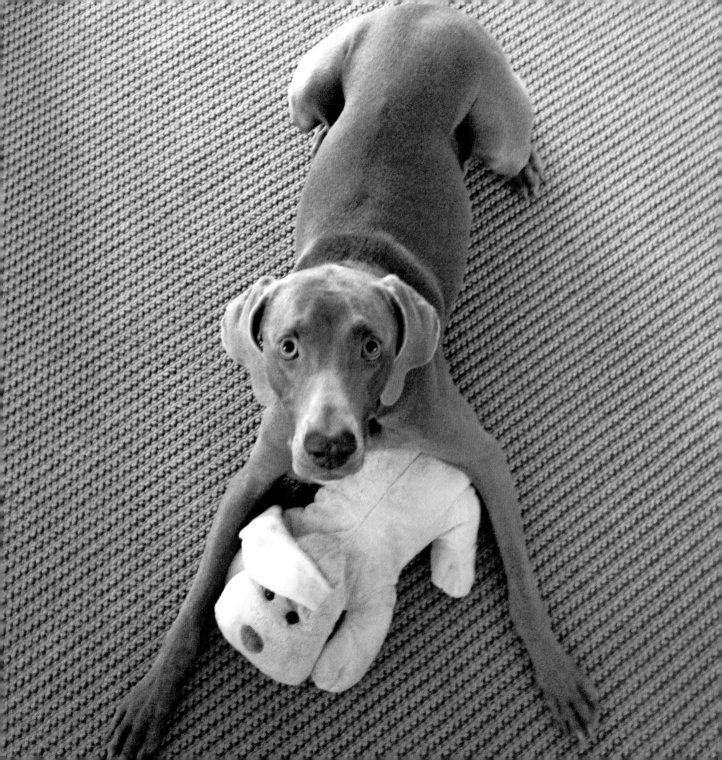

# INDIANA

When my mother and father walked into the house with Indiana, I thought they were holding a replacement for the stuffed bear that I had been destroying all day. But then she walked toward me and introduced herself. None of my toys had ever done that before!

"Hi, my name is Indiana," she said. "What's your name? Do you want to go exploring? I love to explore! Do you like treats? What's your favorite color? Why are your ears so big? Are you an elephant? I like elephants! Can I play with your toys? Are you my sister?"

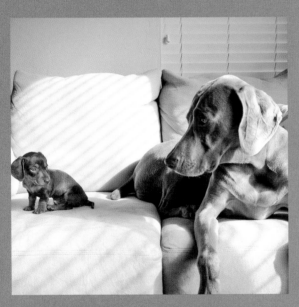
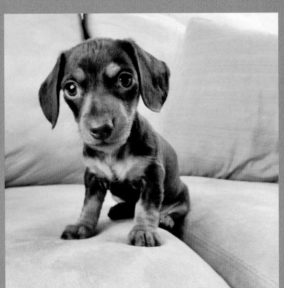

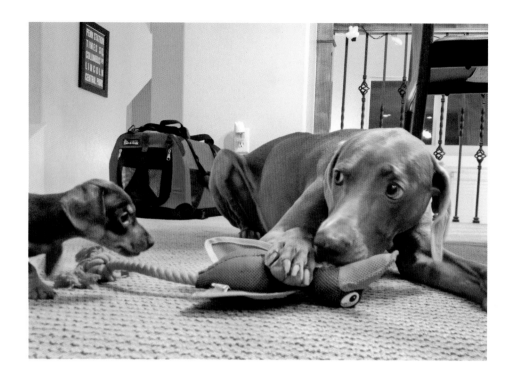

So. Much. Energy. What in the world had those humans done?

I found out that Indiana was only eight weeks old.

"I know she is slightly annoying, but humor her, Harlow," my papa said. "She doesn't have anyone else."

(These people talk to me like I can understand them, which I can, of course. However, when I try to respond, THEY CAN'T UNDERSTAND ME!)

The new addition made itself quite comfortable in my home. She came with her own toys but she claimed all of mine, as well. She took over my couch, my bed, my food bowl, everything.

"IS SHE USING MY TOOTHBRUSH?!" I screamed one evening when I walked downstairs for dinner and saw Indiana lying on her back, chewing on my toothbrush.

"That is so unsanitary, Indiana. Bad girl."

She dropped my toothbrush. She looked humiliated. "What does insanity mean?"

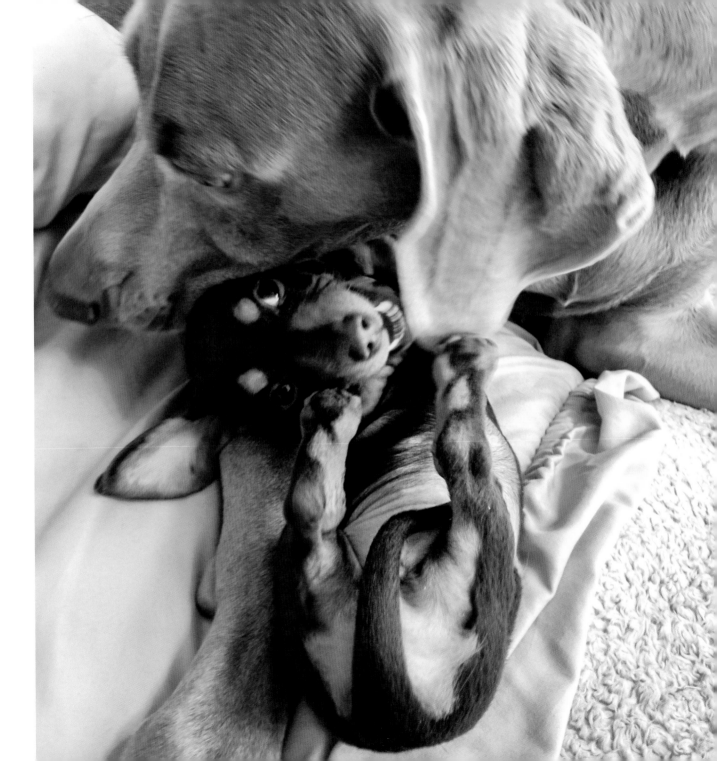

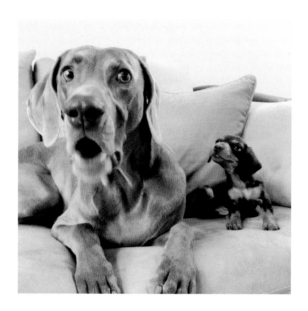

Indi followed me everywhere. She would run up at full speed and bite at my ears for no reason. Why on earth did she think that was acceptable? I didn't understand her, and quite frankly, I wanted nothing to do with her. She really just had so much energy. In the mornings, before coffee, she was jumping and playing and ear-biting and talking. It never stopped!

She asked lots of questions too. "Why would Ferris want to skip school?" "Why did Ross and Rachel break up?" "How many lives do cats really have?" I assumed if I ignored her and pretended she did not exist, my parents would send her back.

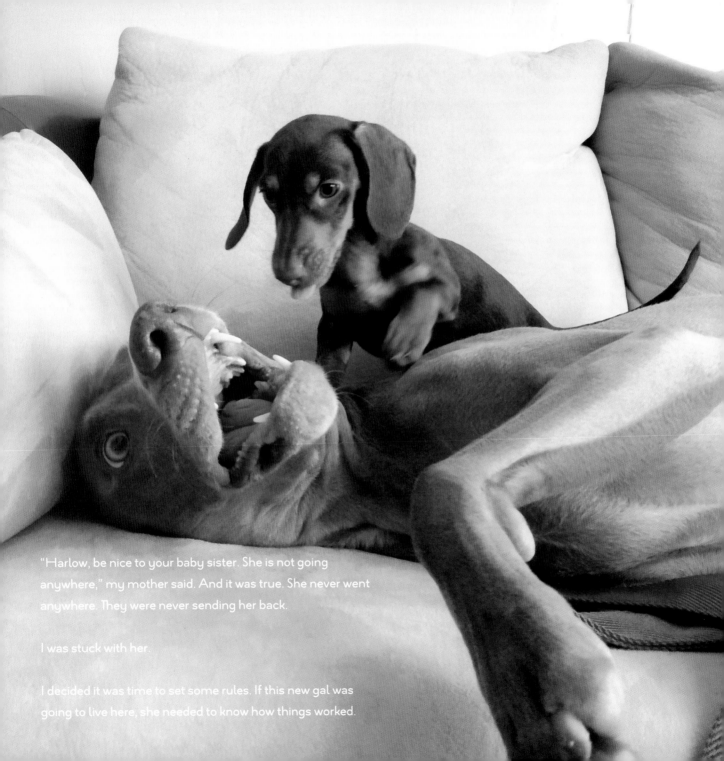

"Harlow, be nice to your baby sister. She is not going anywhere," my mother said. And it was true. She never went anywhere. They were never sending her back.

I was stuck with her.

I decided it was time to set some rules. If this new gal was going to live here, she needed to know how things worked.

The two of us had a sit-down one morning over breakfast.

"Indiana," I began, "if you and I are going to get along, you need to be a little bit more respectful."

"What does respectful mean?"

"It means you don't bite my ears," I explained. "You let me sleep in. You wake up at a decent time, and we read the newspaper in silence. You stop asking me a million questions, and you stay off of my side of the couch."

"But, Harlow!" Indi said. "Your ears are so chewy! I can't read the newspaper because I don't know how to read! Your side of the couch is so comfy! I ask you questions because you are the smartest dog I know!"

She just didn't get it. I missed Sage.

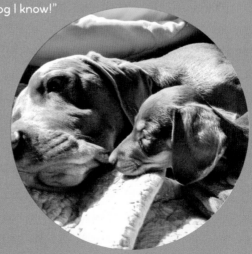

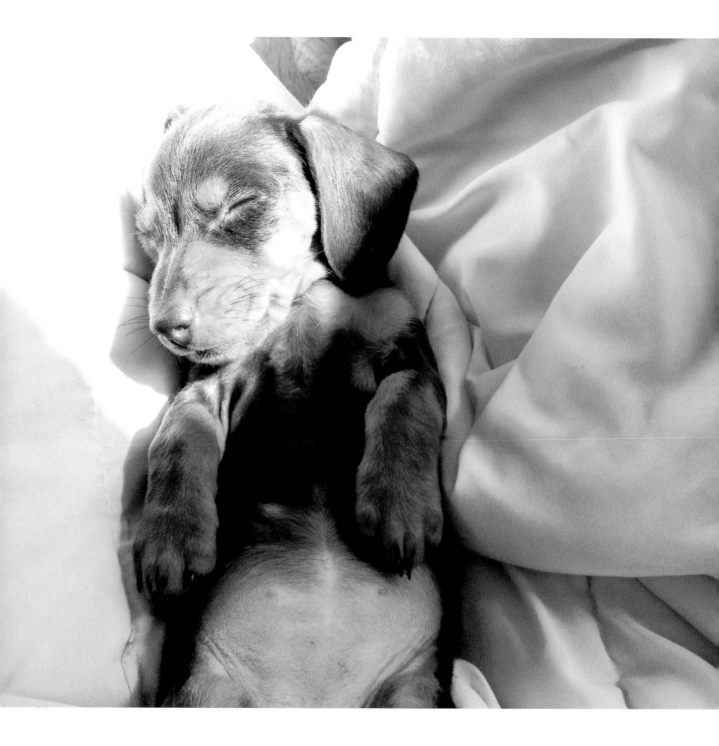

Indiana was small in a way that was slightly cute and incredibly nerve-racking. I had to pay constant attention to where she was or I would have stepped on her. She could fit almost anywhere. One morning I spent the whole three hours of the *Today* show looking for her, only to find her sound asleep under a pile of laundry.

As small as Indiana was in size, she made up for it with her big personality.

She wasn't afraid of anything.

As our first month together went on, I started to get used to Indi. Yes, she was annoying but she was also entertaining. During the daytime, after our parents left for their day jobs, I would sit back and watch as she did horrible things. She dragged toilet paper throughout the house! She chewed up the left shoe of every pair in the humans' closet.

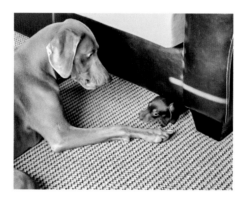

She hid important things like receipts and car keys under the sofa. Once, she dialed 911 from the iPad and when the fire department knocked on the front door, she hid in the hallway closet so she wouldn't get in trouble.

# OCTOBER

## Keeper

By October I decided that I wanted to keep Indiana, and it wasn't just for entertainment purposes. Indi was a good little sidekick. I kind of enjoyed her presence. She was small enough to sneak treats out of the pantry and fast enough to bring them to me without anyone seeing. She still asked a lot of questions but I started to find them endearing. They gave me an opportunity to teach her about life.

"Ross and Rachel broke up because Ross thought that they were on a break! And also so that every time you hear the song 'With or Without You' by U2, you can be reminded of how silly falling in love really is."

"I never want to fall in love," Indi remarked.

"Ferris skipped school because life moves pretty fast sometimes, Indi. If you don't stop and look around, you could miss it," I told her. "And it's important to bond with your best friends."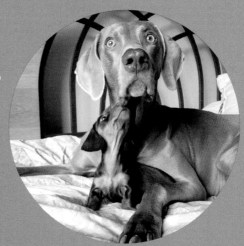

"Like what we get to do every day?"

"Right," I replied.

# SLEEPING LESSONS: PART II

The sleeping situation was a little tricky at first. Indiana was in the process of being potty trained and so she had to sleep in a crate. (The same crate that my parents had unsuccessfully tried to put me in when they brought me home. No matter what anyone tries to tell you—puppies don't like being caged. We are not birds, for heaven's sake!)

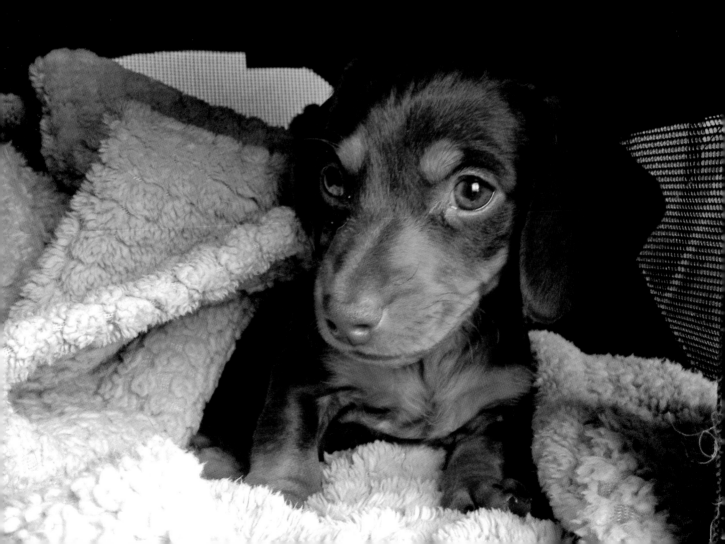

Obviously, Indiana was not a fan of her crate. She would cry all night. It was awful. I could tell that my parents were on the verge of having sleep-deprived mental breakdowns. So was I. And so I took matters into my own ~~hands~~ paws.

The crate was just barely big enough for me to sleep in with the puppy. And so I did just that.

At first my parents laughed. "Oh, Harlow old gal, come out of there!" Papa would say while snapping a picture in an attempt to humiliate me.

I ignored him. I was going to get a full night's rest no matter how silly the situation. And what do you know? With me by her side, Indi started sleeping through the night.

"Please don't ever leave me in this box by myself, Harlow," Indi said before she fell asleep.

Problem solved.

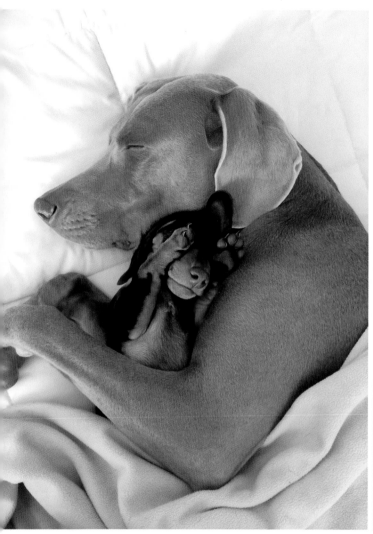

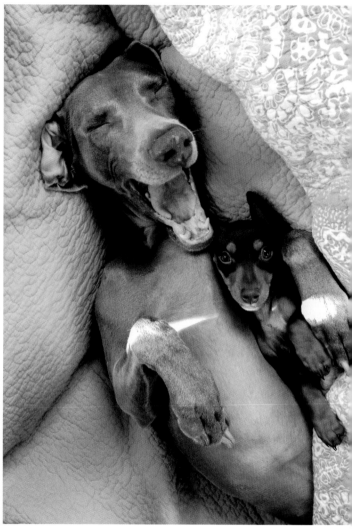

Indiana picked up cuddling real fast. She was a natural. If there were awards for best snugglers, she would win.

At first I didn't know how to cuddle with something so small, but she managed to make herself comfortable no matter how I was positioned. She would lie on my back, my head, and wherever else felt comfortable to her. I had become a living pillow.

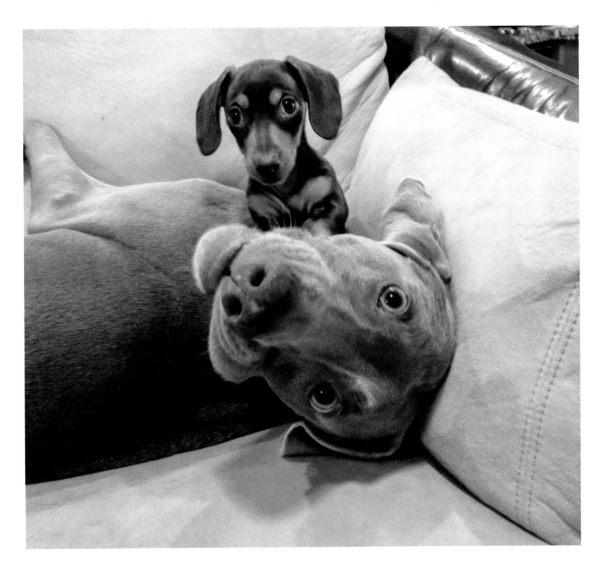

Puppies require lots of sleep, just like the elderly. I was used to that. Sage had definitely gotten her eighteen hours of beauty rest each day.

During the first few months, Indi fell asleep
everywhere.

"Take a picture of this amazing cuddle!" I would say,
wishing my parents could understand me, hoping
that they would be able to capture the moment.
Photographs of dogs cuddling with babies and puppies
and kittens are in high demand these days!

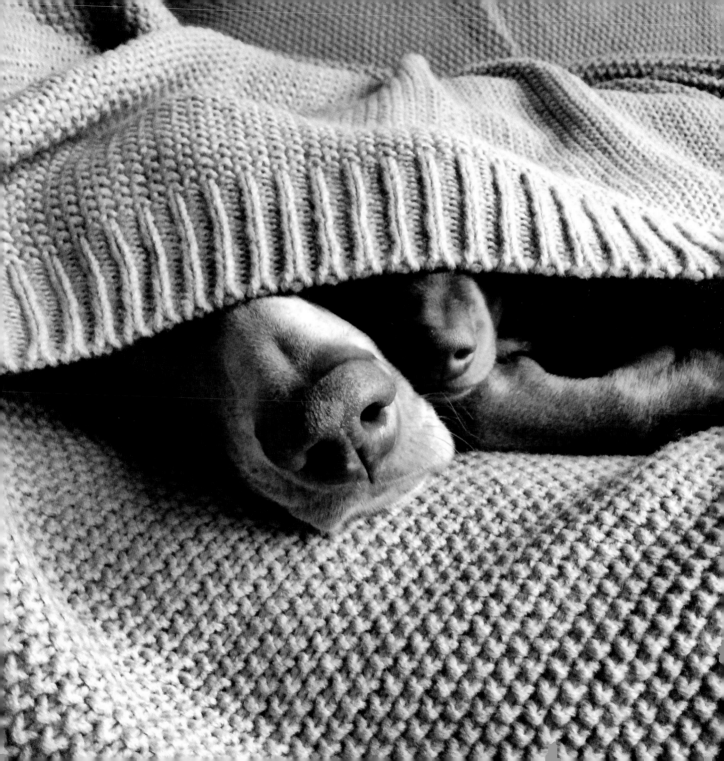

# HARLOWBACK GIRL

When I took Indiana on her first walk, I was surprised by some of the disgusted looks we received from the neighbors. Hasn't anyone ever seen a small child on a leash before?! So I got on the Internet and did a little searching. The backpack I had used to haul Sage around was much too big for little Indi. I needed something smaller.

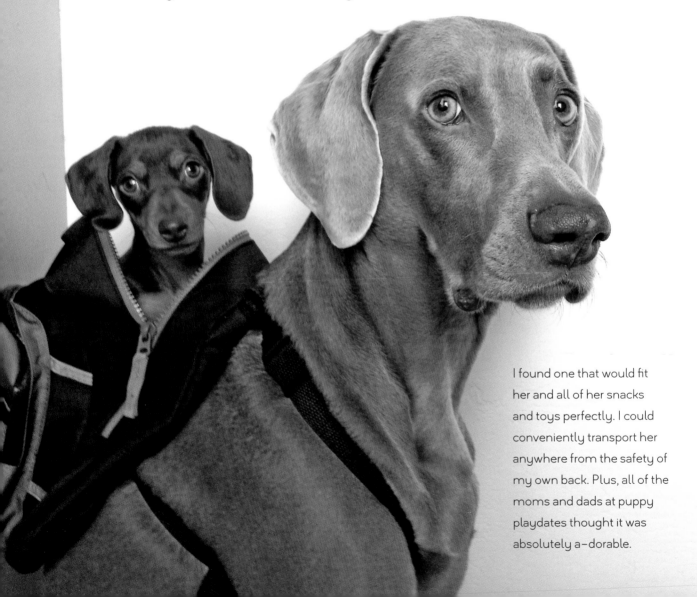

I found one that would fit her and all of her snacks and toys perfectly. I could conveniently transport her anywhere from the safety of my own back. Plus, all of the moms and dads at puppy playdates thought it was absolutely a–dorable.

## MY NAME IS _____

Like most parents, mine sometimes mix up our names. Actually, this issue started with Sage.

Mud on the clean floors: "Sage! I mean Harlow! Did you do this?"

Stuffing from a brand-new toy all over the floor: "Harlow! I mean Indi! Why would you do this?"

To help the parents keep us straight, I took a trip to the craft store and created labels. Other than the fact that I would have to be sitting to the left (of once Sage and now Indiana) in order for them to make sense, they seemed to work out just perfectly.

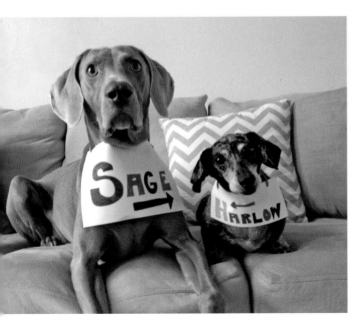

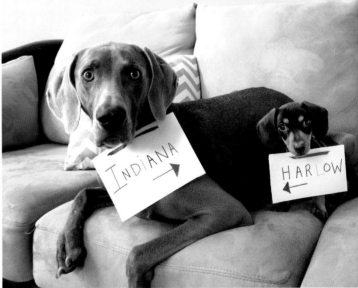

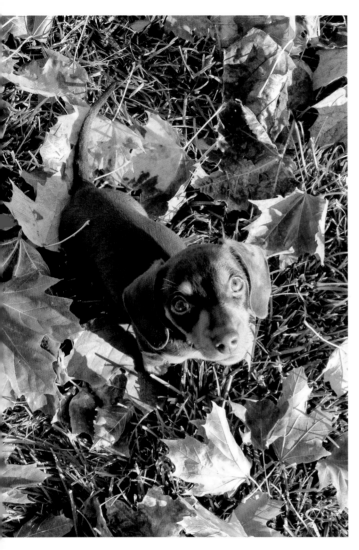

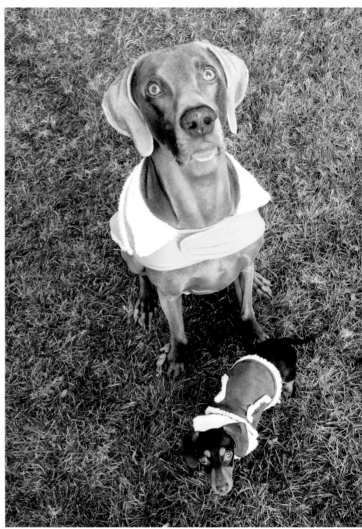

Fall is definitely my favorite season. All of my shows are back from hiatus; I can enjoy the slide at the local park during the weekdays because the kids are back in school; the leaves fall off the trees, turning the ground into a soft bed. And last but not least: sweater weather!

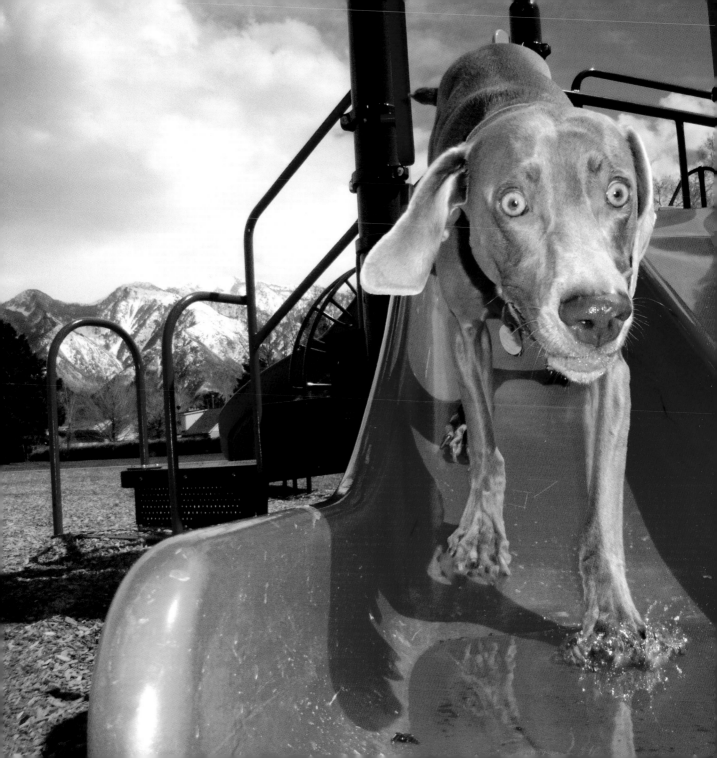

# HAPPY HARLOWEEN

The first Halloween with Indi was extraordinary. It's true what they say about how the best part of having a new baby in the house is seeing things for the first time through their eyes.

I decided that Indi and I were going to dress up as something cute but classy. What is cuter and classier than two bighorn sheep? I ask. That's right. Nothing.

I had stopped trick-or-treating long ago. People get so annoyed when an animal shows up at their front door begging for treats. However, I couldn't let Indi miss out on the trick-or-treating tradition. I wanted her to experience the pumpkins and fall leaves and all the terrifying children walking down the streets dressed as monsters and cows. So I bundled her up and the two of us went out for a good time. She loved it.

When we got home I sifted through her treats, filtering out all the sugar and chocolate and replacing it with healthy treats for growing puppies.

"I want to eat all of the treats in the whole world!" Indi proclaimed while bouncing off the walls. "I wish every day was Halloween!"

A little Harlow-een in training, I thought proudly.

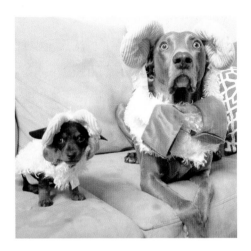

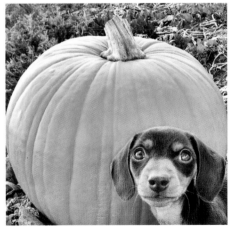

# NOVEMBER

## Short Legs, Cold Bodies

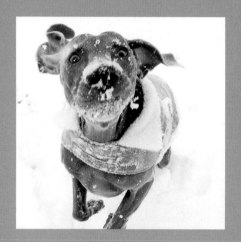

Now, I know that I am tall for a Dachshund. I always have been and it has always felt like more of a blessing than a curse. We live in a community where it snows for three or four months each year. I love the snow.

Sage disliked it because her short little legs caused her torso to practically drag on the ground. It breaks my heart just thinking about it. She would often wait on the patio for me while I played.

I had hoped that Indi would like it, even though she was even shorter than Sage had been. As it turns out, Indi's first time in the snow was a magical experience. She loved it and didn't want to go inside when it was time.

When we finally did go inside, though, she was one chilly dog. And not the kind you eat. Every inch of her was covered in snow and she was shaking like a leaf.

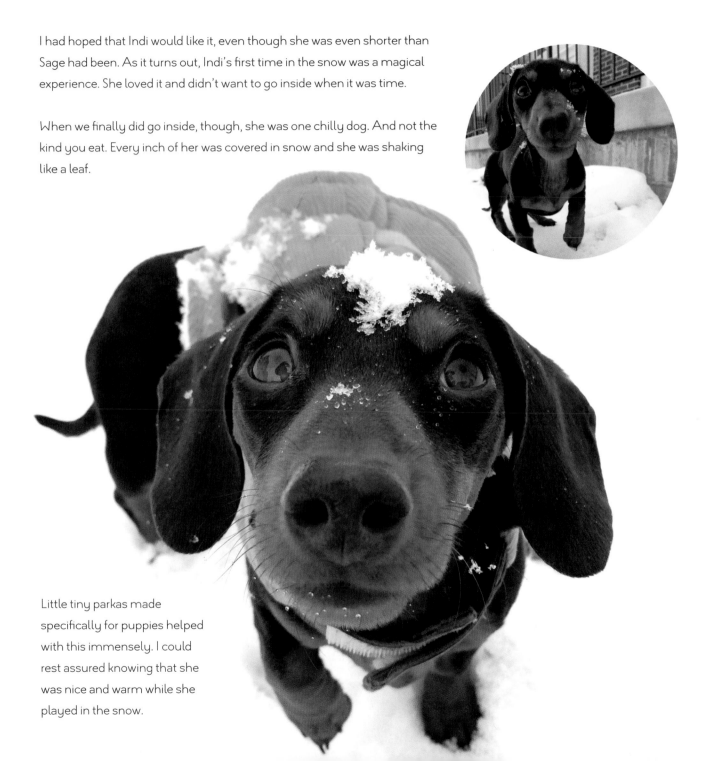

Little tiny parkas made specifically for puppies helped with this immensely. I could rest assured knowing that she was nice and warm while she played in the snow.

## MERYL-ING: PART II

We spent the cold month of November cuddled up inside our cozy home.

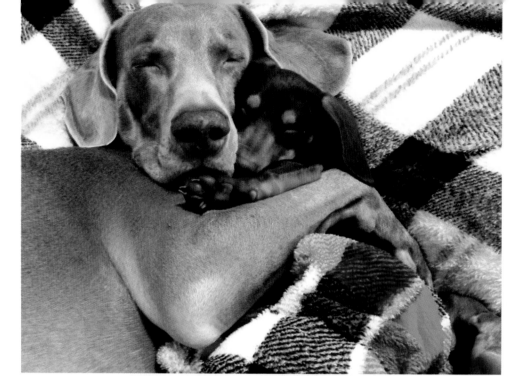

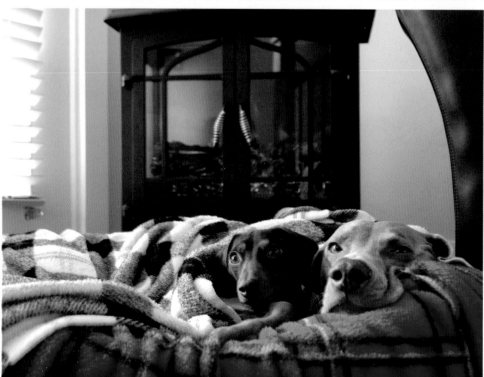

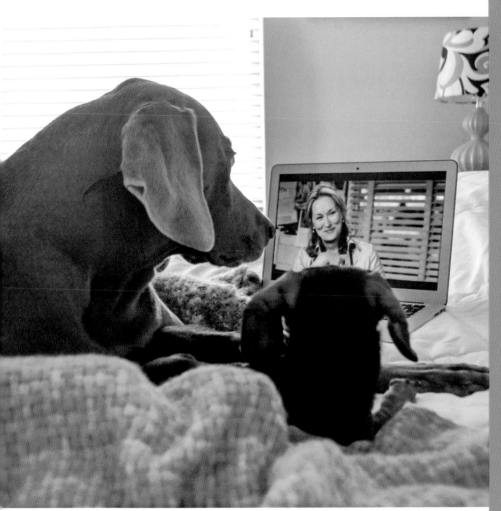

I also spent the month teaching Indiana what to be thankful for. Enter Meryl Streep.

I had not celebrated a Meryl-Movie-Marathon since Sage passed away. It just hadn't felt right up until now. And so the tradition commenced sometime in the middle of the month. And it was a success!

Indi's eyes lit up the second Meryl's face hit the screen. There is just something about that Meryl.

"Why is she so perfect?" Indi asked.

"There are some things in life that we will never have the answers to."

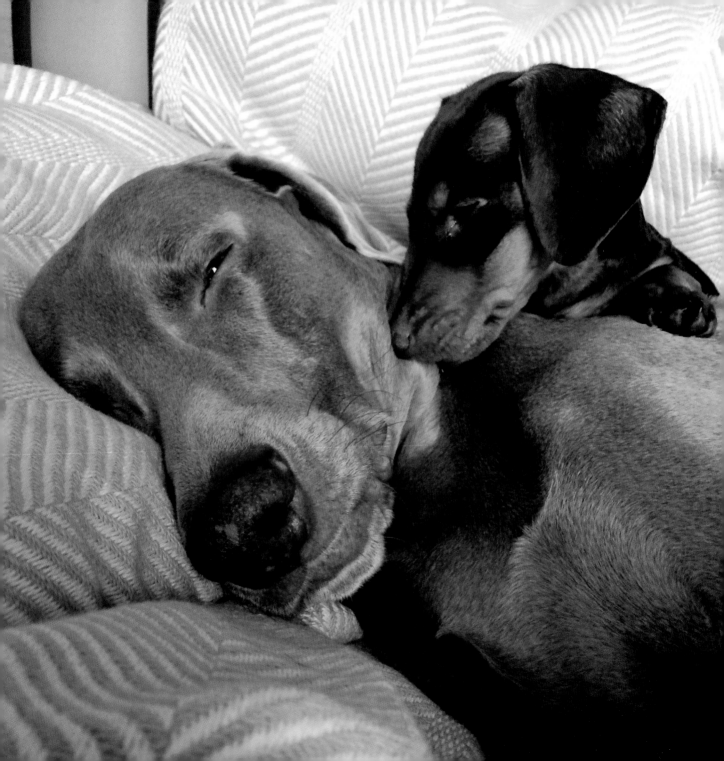

# THE ONE WHERE INDIANA RUINS THANKSGIVING DAY

Thanksgiving morning is a splendid occasion at our house. Harlow and Sage Tradition was to sleep in until five minutes past eight, take a family walk, come home and relax while our parents drank their mud, and then we would all gather around the television and watch the Macy's Thanksgiving Day Parade.

But Indiana had other plans. On this particular Thanksgiving Day she decided that she wanted to eat a set of pillows. Not just any pillows . . . feather pillows.

Thursday, November 28, 2013, approximately 5:00 a.m.

"Harlow, it's me, Indiana. Please wake up. Harlow. Harlow. Harlow. Harlow."

Let me tell you something very important about myself. I am the most easygoing creature that ever lived. But when I get woken up early, especially on Thanksgiving Day, I get upset. Very upset.

I opened my eyes. "WHAT! WHAT! WHAT!"

"There is snow all over the living room," Indi whined. "There is snow covering my body." And then she ran off.

By now I was fully awake. I lumbered out of bed, did my morning stretch, and entered the hallway. I could feel it under my feet as soon as I began to walk down the stairs. When I reached the living room, I could see it. Everything was covered in feathers, including Indiana, who was now standing beside me.

"Why oh why would you do this?" I asked. I was furious.

"I'm sorry, Harlow," Indi said quietly.

When my parents woke up, Indiana was sent to time-out. All. Day. Long. And I spent my Thanksgiving Day watching my parents clean feathers off every inch of the house.

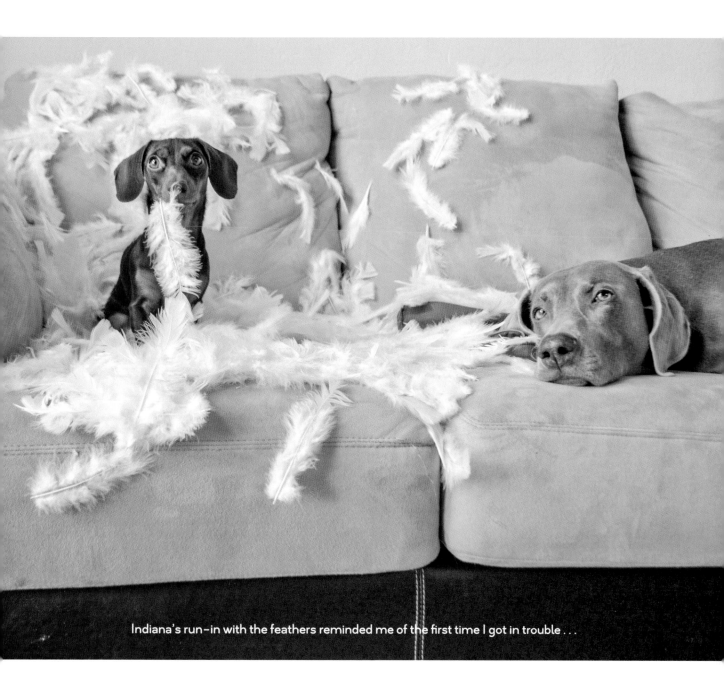

Indiana's run-in with the feathers reminded me of the first time I got in trouble . . .

# SEAFOOD

I have made my mother cry only once in my lifetime. It was also the only time I have ever sat in time-out.

For as long as I can remember, we have always had a family fish. When one retires, it is replaced by another. These fish are always named Desi. We started with Desi 1, then Desi 2, then Desi 3, and so on. As of this moment in time we are the proud owners of Desi 6.

Sometime during the life of Desi 2, I got a strange craving. Don't worry, it wasn't for seafood.

It was for fish food.

The week before my craving, my mother and father had brand-new carpeting put down in the hallway. It was the most beautiful shade of beige. My mother loved it.

On the day of my craving, I did the forbidden and went counter-surfing. I was thrilled to see Desi 2's fish food sitting so close to the edge. I could reach it just perfectly! I took the container in my mouth and lay down with it in the hallway. When I finally got the lid off, red flakes spilled everywhere. I licked up every last one.

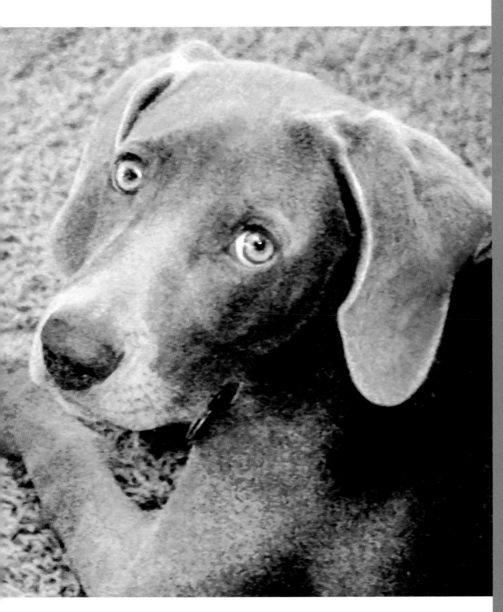

I realized when I finished eating that:

1. My stomach felt awful.
2. The new beige carpet was now red. (If you think that dogs are color-blind, you are mistaken. We are not. It's a myth.)

I went and hid in the closet.

My mother and father had gone out for the afternoon.

When I heard the front door open, I closed my eyes and pretended I was invisible.

There was no yelling. Just silence. And then tears. And then the sound of the carpet cleaner.

I finally came out of my hiding spot and looked at my parents. Whatever they had done with the carpet cleaner had only made matters worse. But I didn't say anything. Instead I went back to the closet, and that is where I spent the rest of my evening. There were no treats that night.

# SMELL-BLIND

"But, Papa! I am smell-blind!" Indiana cried as our father carried her to her regular place in the house for time-out.

Indiana's newest trick was sneaking up onto the kitchen table and eating things that she wasn't supposed to eat. She would tell me that, because she was "smell-blind," she couldn't tell the difference between her puppy chow and human food.

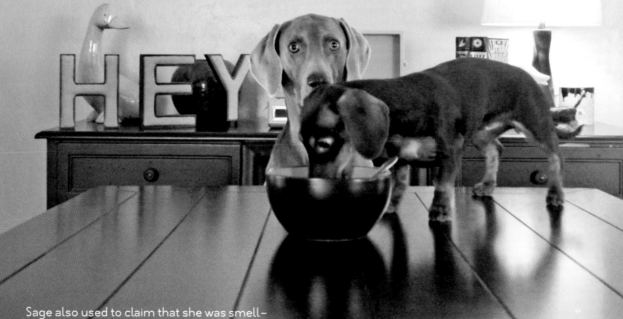

Sage also used to claim that she was smell-blind. However, I actually believed Sage. She had good reason.

Back in the olden days, I would go to day camp. It was a place where I could get rid of my energy when my parents needed a Harlow break. Sage never went to day camp because the day camp is connected to our animal hospital and Sage despised the place. She would whine whenever we pulled into the parking lot and hide behind our mother when we walked inside.

"They will almost always stick a sharp object into your behind," Sage explained.

One Friday morning my mother dropped me off at day camp while she went to work.

Sage stayed home.

I was having the time of my life playing with an Airedale terrier named Jeffrey when suddenly a doctor came running by us, pushing a small black dog on a gurney.

"WE GOT A BLEEDER!" he yelled as he ran past us.

"Hey, Harlow," Sage said from the gurney.

"Hey, Sage," I responded in disbelief.

The doctor pushed Sage through the doors that led from the doggy playground to the operating room. "COMING THROUGH!" he shouted.

"It's like an episode of *Chicago Hope*!" Jeffrey said excitedly.

"That was my sister," I said.

"No way! Awesome!" Jeffrey responded.

"I don't want to play with you anymore, Jeffrey," I said, and I went to the corner and sat down. I was upset.

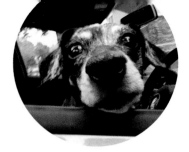

I waited in the corner all afternoon.

Finally, my father walked in. "Come on, Harlow. Gather your belongings. It's time to go home."

I was relieved when I saw my mother waiting with Sage in the car.

"What happened to you, Sage?"

"I was attacked!" she replied. "I was minding my own business in the backyard when I heard something strange at the neighbor's house. Out of curiosity, I stuck my nose through the fence and BOOM! Before I could pull back, it had my nose in its beak!"

No wonder her nose looked crooked, I thought.

"The next thing I remember was waking up in the emergency room."

"The chicken," I said quietly.

"The chicken," Sage repeated.

Our neighbors had a pet chicken that for some odd reason hated me and Sage.

I had tried on multiple occasions to talk to it but it would just stare at me. Super awkward, I know.

When we got home, I walked outside to the backyard.

"You really hurt my sister," I said through the chain-link fence.

"Your sister shouldn't go sticking her nose in other people's business," the chicken replied while walking to its coop. Then it turned around and shot me a glare before walking inside.

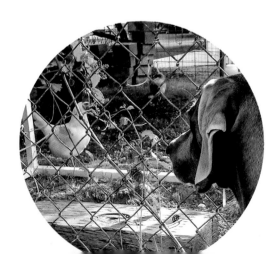

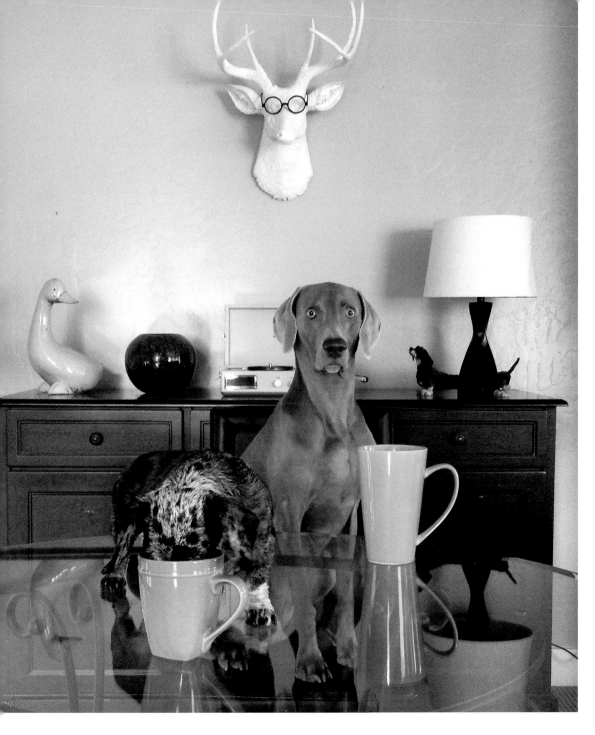

After that, we never went anywhere near the fence again.

And as a result of her injuries, Sage went smell-blind.

# OUTSIDE FURNITURE

Once, I tried to bring a large stick into the house. "STOP RIGHT THERE, HARLOW!"
my mother yelled from across the room. "YOU PUT THAT TREE BRANCH DOWN,
HARLOW!"

I stopped. Not because my mother was throwing a fit but because this so-called "tree
branch" was too wide to fit through the front door.

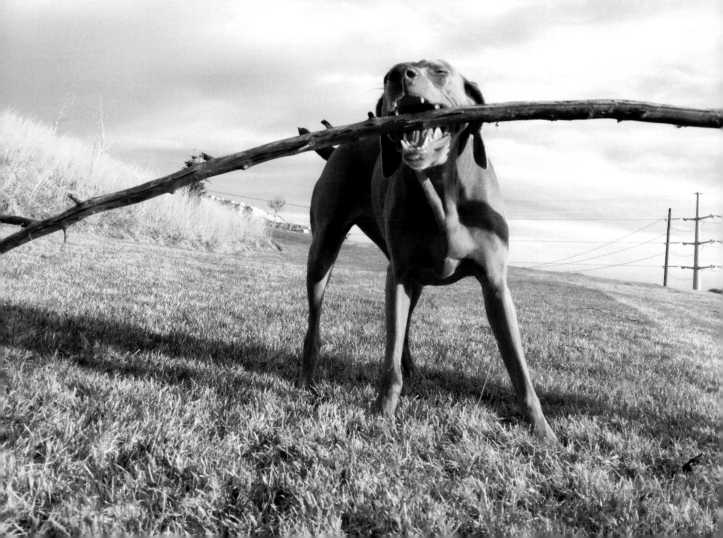

"I saw her stand up on two legs and pull that branch right off the willow tree! What was she thinking? With her teeth, even! It was like some sort of barbarian had taken over!" I could hear my mother telling my papa.

I lay down beside the branch on the front porch. It was twice my size. I wanted to take it inside so badly. My parents were so impractical sometimes.

I stayed on the porch with my branch until dark. I was sulking. I wanted my mother to apologize. I wanted her to find a way to fit my branch through the front door so that I could chew on it in the living room while I watched my shows. I was missing *30 Rock*, for heaven's sake!

Finally my mother came out and sat down next to me. "Harlow, you can't bring things that belong outside into the house," she said while putting my most favorite fruit snacks down in front of me. "We will keep your branch right here and you can come play with it tomorrow. Now come inside, you crazy dog!"

Whatever, lady.

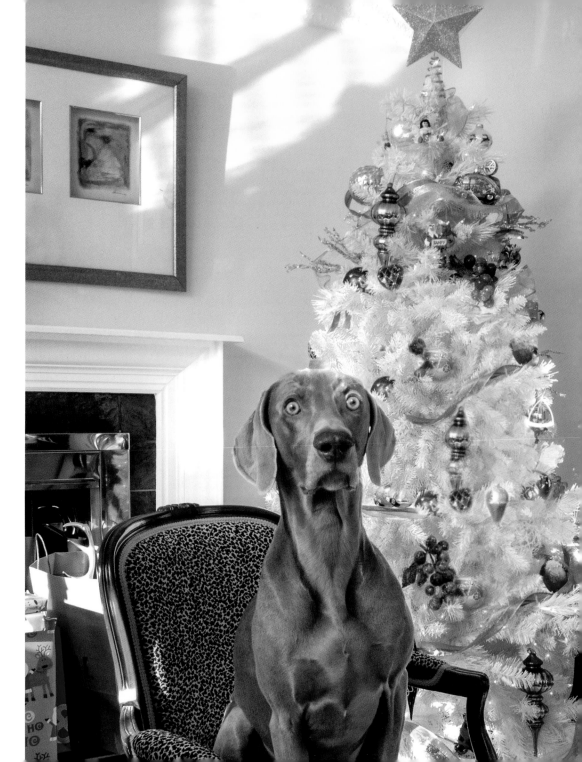

Okay. So now you can hopefully understand the frustration I was feeling when my parents walked through the front door carrying . . . drumroll, please . . . A PINE TREE.

"Come look at your new Christmas tree, girls!" Papa said with excitement.

Indiana looked at me in horror. "Why are they bringing outside furniture into the house?" she whispered.

I didn't answer her. I was in awe. I had seen pine trees in the house before. However, in the past these pine trees were fake and consisted of metal and plastic. We had never had a REAL Christmas tree.

"WE ARE NOT THE GRISWOLDS!" I yelled.

"Quit barking at me, Harlow. You know better than that, old gal!" Papa scolded.

"I love the Christmas tree, Papa!" Indi said.

"Stop brownnosing," I told her.

"But my nose is brown!" she said matter-of-factly.

"QUIT MOCKING ME!" I shouted, and ran upstairs.

"She's so dramatic," I overheard my papa say.

Thankfully, Indiana ended up having some sort of allergic reaction to the pine tree and we were able to put the fake one up instead.

# MERYL CHRISTMAS, INDIANA

Indiana was staring at me when I opened my eyes on Christmas morning. "Meryl Christmas, Harlow," she whispered.

I looked up at the alarm clock. 5:31 a.m.

I could hear my papa snoring.

"Go back to sleep, Indiana. It's too early," I replied.

"But I am so excited! I can't sleep anymore! It's Christmas, Harlow! WAKE UP!!!"

"Indi! Quiet. No barking," my mother yelled down from her bed.

I knew Indi was not going to go back to sleep and I couldn't blame her. I remembered feeling this same way on my first Christmas. What had Sage done for me? I thought. And then I remembered . . .

As was her yearly custom, our mother had put out a plate full of Milk-Bones and a saucer of milk.

"These are for Santa Paws!" she explained.

"Just go with it," Sage said. "In the morning it will be gone and she will think that she has tricked us into believing that Santa Paws really ate the Milk-Bones and drank the milk. But really, she just dumps out the milk and puts the bones back into the treat jar."

This year, as I lay there with Indi on Christmas morning, I realized that we had about two hours until our parents would be awake, calling us down to the living room to come and unwrap our presents. (Note to parents: Wrapping paper is a magical thing, especially for dogs. Please don't ruin the magic by putting presents in gift bags.)

Our mother had pulled her usual trick the night before. "Look, Indi! These treats are for Santa Paws!" she explained to her in a baby voice. Indi still believed in Santa Paws and I hadn't wanted to ruin the big secret.

Now I said to Indi, "Follow me," and led her downstairs to the kitchen. I jumped up onto the counter.

The biscuits and milk were still there.

"Look, Indi, Santa Paws forgot to eat his treats!" I said as I ate a few and used my paw to scoot the plate to the edge of the counter. Fifteen Milk-Bones conveniently dropped one by one to the ground in front of Indi. The

two of us ate every last one of them. The joke's on Mother this year, I thought.

"If you are very quiet, I will let you open one of your presents early," I told Indi.

"Really!?" she whispered excitedly.

"Yes, but you have to be quiet and you can only open one. Deal?"

"Deal!" she agreed.

Sage let me do this same thing on my first Christmas. We snuck downstairs, I opened my one present, and then we went back to bed and waited for our parents to get up. I was such a wonderful listener.

"That one!" Indi said, nudging a small box with a tag that read "Indiana Thunderbolt" on top of it.

"Go for it, kiddo!" (I call her kiddo because it makes me feel wise.) Indi ripped open the paper and bit through

the box as fast as she could. "A leash! Harlow, a leash!" she squealed.

Poor little thing. Only gets to open one and it's a leash. I should have feigned excitement, but how could I? A dog getting a leash for Christmas is like humans getting pennies on Halloween.

"Why don't you go ahead and open another one, Indi."

And she did. And if you guessed that it was a collar to go with her leash, you were right!

"Keep going until you get to something fun," I said.

This made Indi very happy, and before I could blink, she was tearing through all of her presents.

And then suddenly she stopped. And her eyes got very big. And when I turned around, I understood why. My parents were standing behind us.

"Harlow, we are both going to get sent to the pound," Indi whispered.

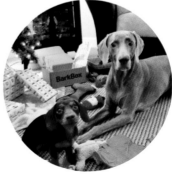

To my surprise, Indiana and I did not get sent to the pound that Christmas morning.

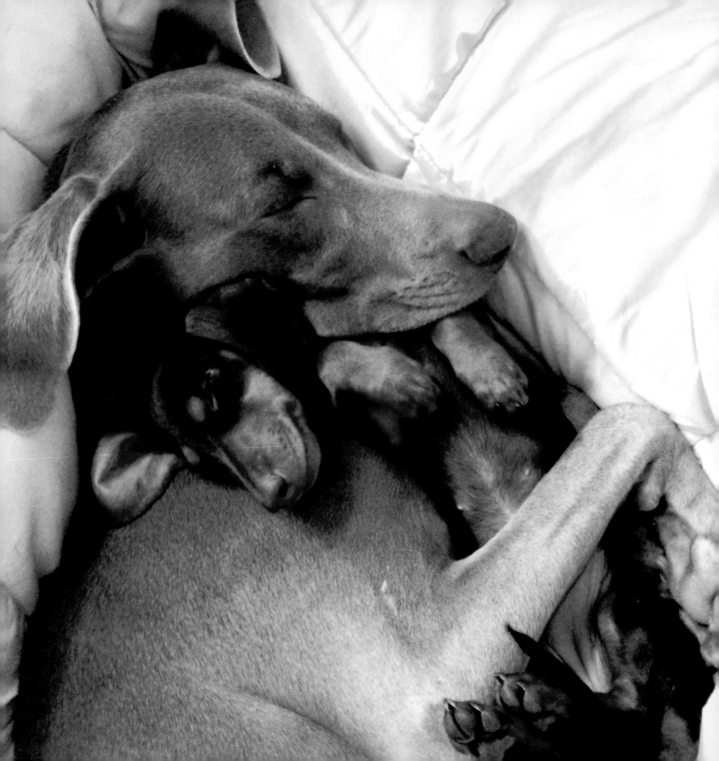

New Year's Eve came and went. Indi
and I spent ours doing what everyone
else does. Sleeping.

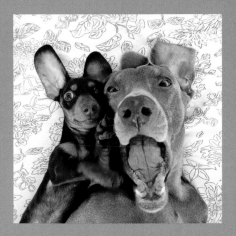

And we spent New Year's Day doing
what everyone else does.

Celebrating.

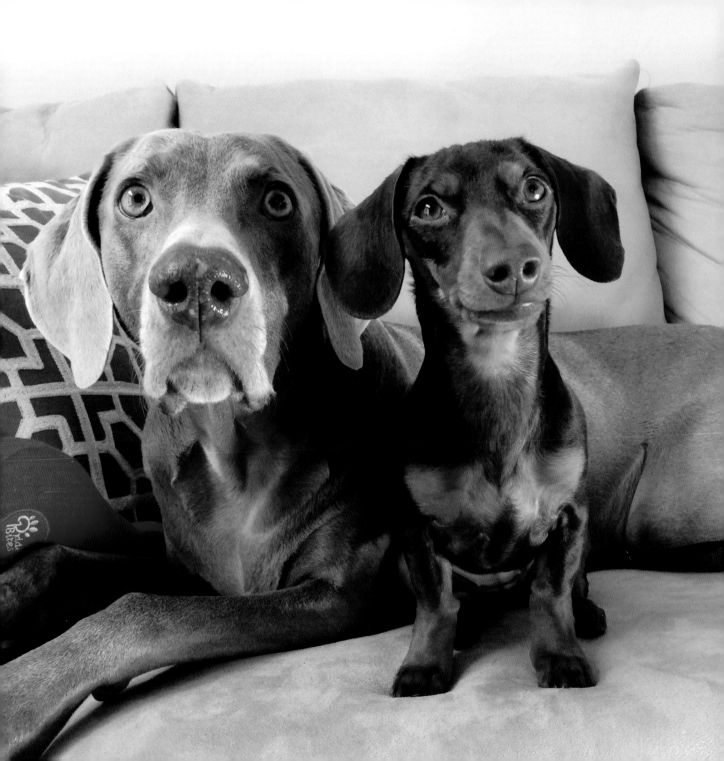

# JANUARY

"Do you know why January is such a special month?" I asked Indiana.

"January is the month when Oscar nominations are announced!" she said proudly.

She really was well trained.

"Yes, Indiana! Good! But why else is January a special month?" I asked again.

"YOUR BIRTHDAY!"

"Indiana! No barking!" my mother yelled from the other room.

"That's right!" I said to Indiana. "My birthday."

"You are turning six this year. Practically over the hill in our years," Indi said to me.

I was not self-conscious about my age. Getting older is something that I was embracing with grace. Just as Sage had done. (Just as Meryl is doing.) Besides, I didn't feel old. I could still run faster than Indi. My skin looked flawless. And my hair had always been gray, so that was never going to be something I had to worry about.

"Let me tell you something, Indiana," I replied. "One of the most important things I can teach you is that you never tell a lady she is old. It's rude."

"Oh," Indi said ashamedly. "I didn't know."

I instantly felt bad. She *really* didn't know any better. She was still a puppy. It was at that moment I realized I needed to teach my little sister some lessons.

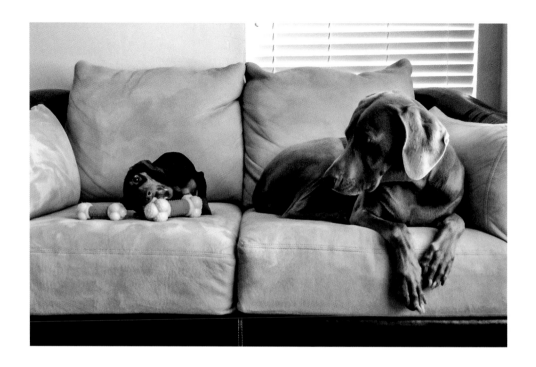

## SHARING

"What's mine is yours," I told Indiana.

"Yes! What's yours is mine. And what's mine is mine," she said smugly.

"No. We share," I said as I took my favorite toy from her.

"I hate this game!" she whined as she took the toy back.

(To this day, Indiana does not know how to share.)

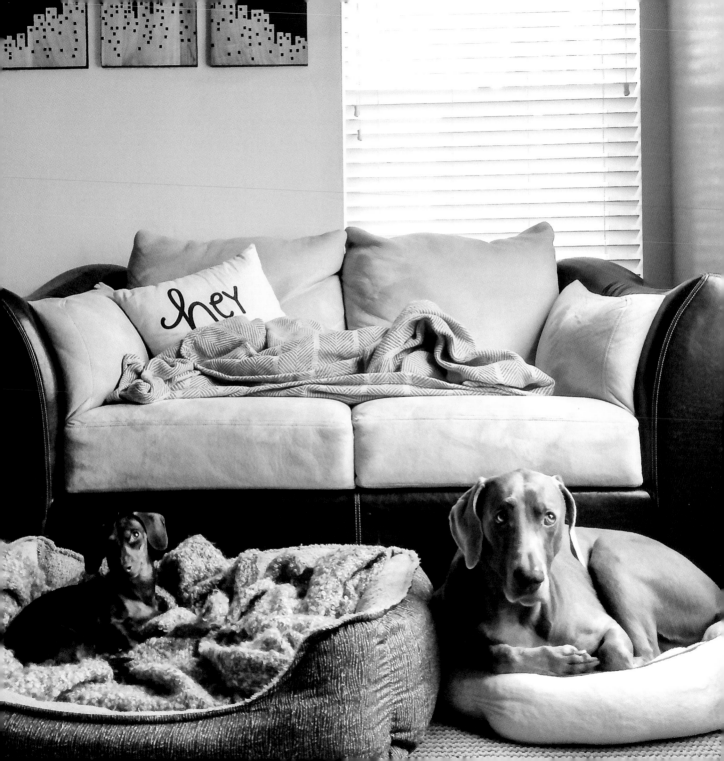

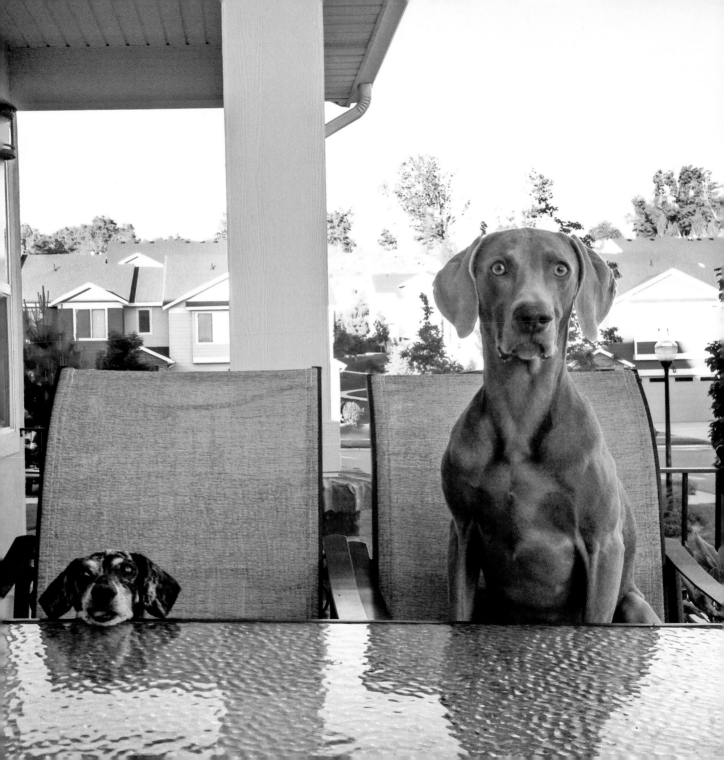

# TABLE MANNERS

"Good table manners are an absolute must," Sage had once explained to me. "You don't want to be the only gal at a dinner party with your paws on the table. Paws stay off the table, Harlow. And no barking at the table. We wait patiently to be served."

Indiana struggled with this concept. Puppies these days, I thought to myself.

With lots of practice, though, she figured it out.

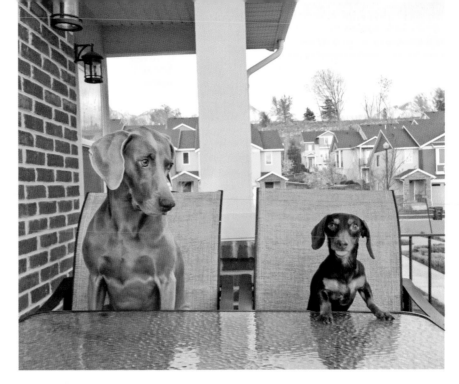

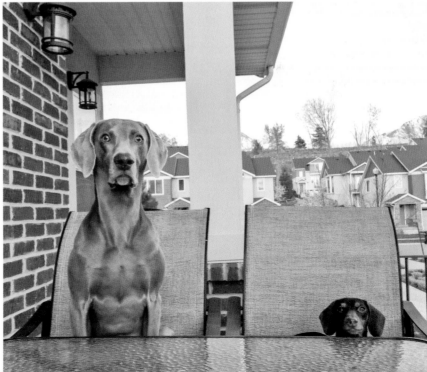

# HONESTY

My mother had torn apart the entire house looking for her left running shoe. For two weeks she had gone through every closet, cupboard, and drawer. She moved furniture, looked under the couches, under the beds. She had even gone through the garbage cans. Indi and I watched as she wandered around the house searching.

"I know you know where it is, Indiana," she would say each time she walked by us.

"You really need to give up that shoe," I told Indi.

"I don't know what you are talking about," Indi replied.

"Lying is a horrible thing to do," I said.

"I DON'T KNOW WHAT YOU ARE TALKING ABOUT!"

Later that day, when Indi was having a dog-nap, I moved her favorite toy, a hideous stuffed bunny that she called Mr. Fanortner, underneath the sofa.

It took her a few days to notice that Mr. Fanortner was missing. But when she finally did, I watched her go to each room in the house, checking under every bed and couch.

"Have you seen Mr. Fanortner?" she finally asked me.

"I don't know what you are talking about."

"TELL ME WHERE HE IS!"

"TELL ME WHERE MOTHER'S SHOE IS!" I screamed back.

"Girls! You know the rules. No barking in the house," Papa yelled from upstairs.

Indi and I rarely fought, but when we did, our teeth came out. It was just more intense that way. We both sat now, baring our sharp ones at each other.

Indi finally broke down. "It is hiding at the bottom of the toy chest."

"You lied to me," I scolded her.

"I wasn't ready to give it back," she said sadly.

"No more lying, Indi. It's not a nice thing to do."

"Everyone tells lies, Harlow!" she replied. "When Mother cooks dinner and asks if Papa likes it, he says yes. But then he hands us his food underneath the table so that he doesn't have to eat it."

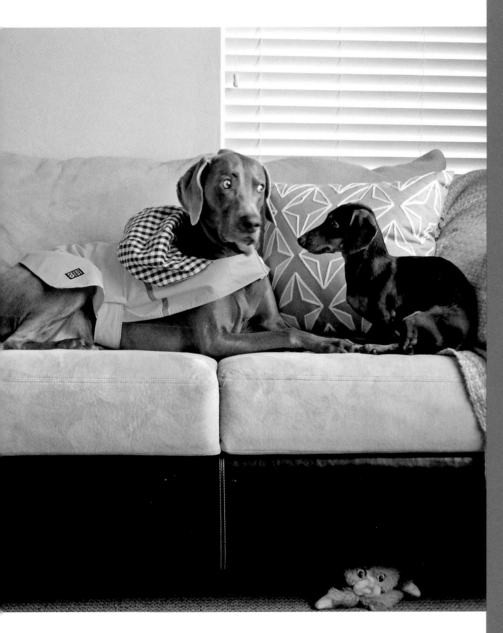

I wasn't quite sure how to respond. What would D.J. tell Stephanie and Michelle if she were in my shoes? I wondered.

"Indiana, there is good lying and there is bad lying," I explained. "When someone's feelings get hurt, that is bad lying. When you lie to make someone feel better, that is good lying."

"Like when I tell you that you look good in yellow, but really, yellow just isn't your color, that is good lying?" she asked.

"Well, yes," I said.

I did not like this conversation anymore. "Look, Indi, lying is bad either way. And so is hiding people's things. Don't do it anymore."

"Okay. I promise," she said.

"Do you really think I look bad in yellow?"

Long pause. "No, you look wonderful in yellow."

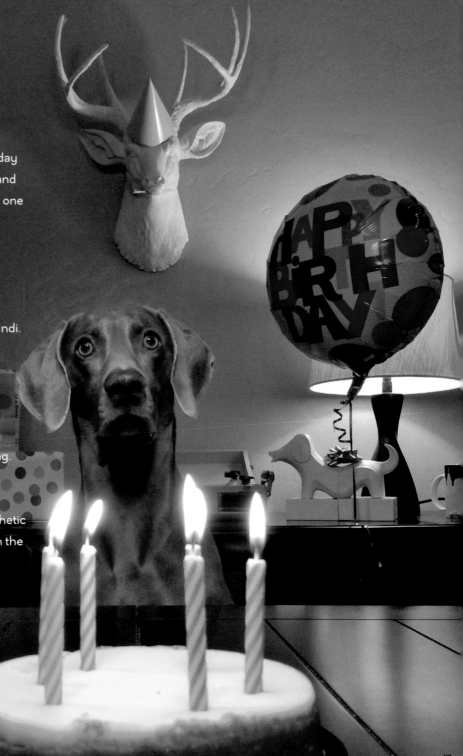

## HAPPY BIRTHDAY, HARLOW

My parents made sure that my birthday turned out fabulous. There was cake and laughter and presents and, of course, one small tantrum.

"Why don't I get any presents?" Indi wailed.

"Because this isn't your special day, Indi. It's mine."

"But I am special," she replied. And then . . . she did the unthinkable. She sent HERSELF to time-out. And for over an hour she stayed there. Pouting. Whimpering. Manipulating.

My parents both stared with sympathetic eyes at Indiana, sitting pathetically in the corner.

"Oh, poor baby! She must feel so left out," my mother said sadly.

Ugh! I thought. I knew exactly what that little brat was doing. What a horrible ploy for attention. I couldn't believe it was actually working. Humans can be so gullible sometimes!

My father stood up. (Right in the middle of cake and ice cream!) "I will be right back!" he announced before getting into his car and driving off.

I watched through the window for him to return. Finally I saw him pull up.

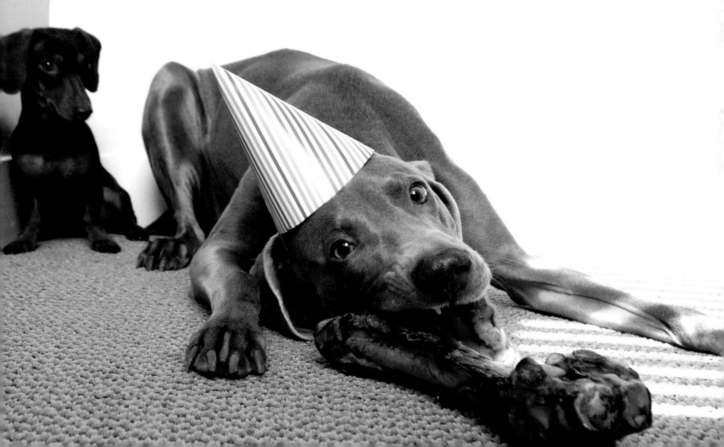

With the sun setting in the distance behind him, my father walked up the steps to our front door like a knight in shining armor, hands full of bite-size toys and bones for my baby sister.

Indi, with her tail wagging obnoxiously fast, greeted him at the door. "Here you go, baby!" my father said in that ridiculous puppy talk.

As I turned to walk back into the kitchen to finish eating my cake, I looked at Indi. She smiled at me and then winked. "Creep," I muttered under my breath.

Little sisters can be the absolute worst sometimes.

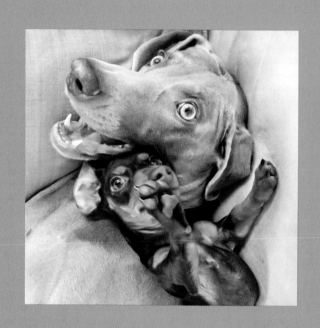

Oscar nominations were announced at the end of January.

"Hooray!" I shouted.

"Yippee!" Indi squealed.

Meryl Streep had just been nominated for her eighteenth Academy Award. The news was so delightful that we couldn't contain our excitement! I wanted to shout it from the rooftops!

Somewhere, Sage was smiling. This news would have made her very happy.

# FEBRUARY

## The Bath

Playing in the bath has always been one of my favorite pastimes. What can I say, I love the water!

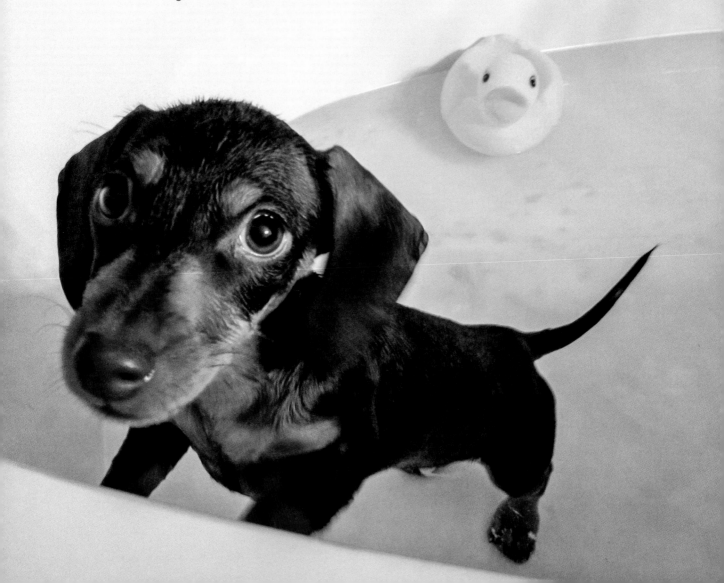

Sage dreaded taking baths. The second she heard the water running, she would head for the hills! (Or under the nearest bed.)

By now, I think it was safe to say that Indiana liked taking baths just as much as I did. It took some coaxing, of course. If I wasn't in the bath with her, her collection of rubber ducks had to be.

She does not like shampoo. Applying it is a team effort that requires lots of focus from both of my parents. One of them has to be giving her treats while the other lathers her fur.

Perhaps the most wonderful part of witnessing Indi's bath time is the after-party that takes place the moment she gets out of the tub and her feet touch the bathroom tile. Indi's ritual is to run a race through the entire house, burrowing under blankets to try to get her hair dry.

"Indi, just let them blow-dry your hair, it is much easier!" I tell her as she speeds by me.

"NO! MUST. GET. DRY. BEFORE. MY. BODY. MELTS," she says as she rolls around on the carpet trying to get her back fur dry.

For whatever reason, my baby sister assumes that when water touches her skin, she will melt.

Valentine's Day is not an occasion to be celebrated by dogs:

(A) Humans always go out for a night on the town.

(B) The day is celebrated by eating chocolate.

Indiana and I spent the evening watching *Weekend at Bernie's* on Netflix. It was perfect.

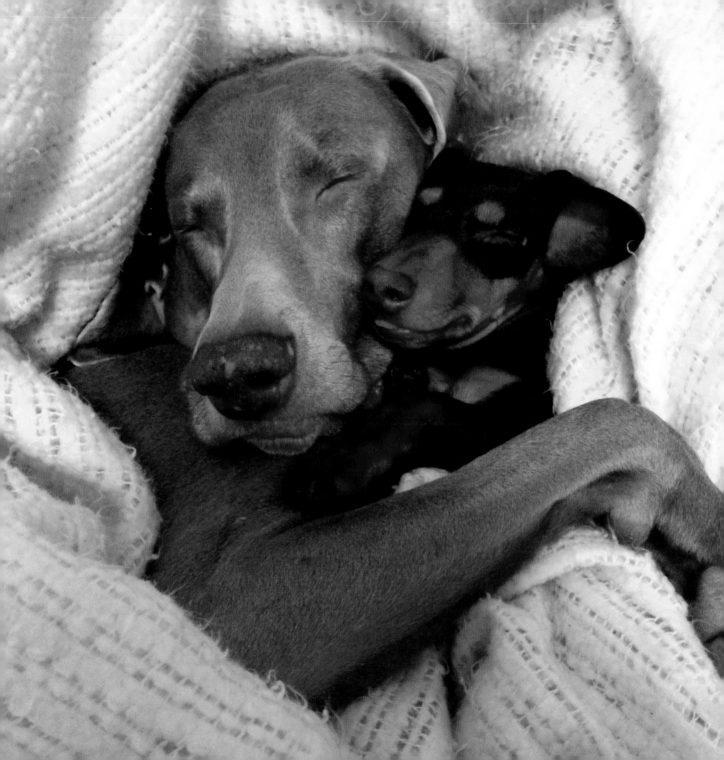

# QUESTION MARKS

"Why do some years have an extra day?" Indi asked me one afternoon.

"It is called a leap year, Indi," I answered.

"But what *is* it?" she said, displeased with my original response.

I froze. I did not know the scientific reason behind the leap year. I was embarrassed.

I was six years old—middle-aged, for crying out loud—and I had absolutely no idea how to explain a leap year. I knew the basics. It happens every four years. If you were born on February 29, most states wouldn't recognize your birthday until March 1.

But as far as an explanation, I was stumped!

What else would I not be able to explain to her? What if I wasn't as smart as she thought I was? Had I failed my little sister?

Later that night, I had a dream.

I dreamed that I was sitting in the living room on my couch (the one I always sit on), watching television. Suddenly, static. And then . . . Sage appeared.

Oh my goodness. *Poltergeist*, I thought.

"I'm heeeeeeeere!" Sage said happily.

"Sage? What are you doing in the TV?" I asked.

"Hi, Harlow! How are you, girlfriend?" Sage said.

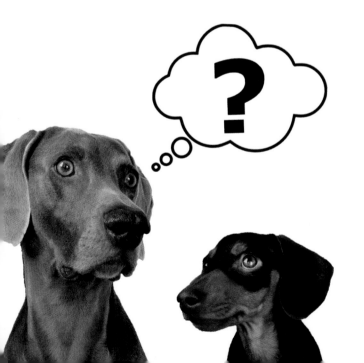

d," I whispered. I was in shock. "Sage, why are
n the TV?" I asked again.

he only way for me to get information to you,"
ld me. "Harlow, it is okay that you don't have
e answers for Indiana. You are not a failure. Just
ur best. She will love you no matter what."

s you, Sage," I told her.

you too, Harlow," she replied. "I must go now.
s an all-you-can-eat buffet that I am missing
I love you, HarHar."

"I love you too, Sage," I said.

And then she was gone.

The next morning, Indiana and I looked up the real
explanation for leap year.

"I love you, Harlow," Indi said to me after I finished
reading it to her.

"I love you too, Indi."

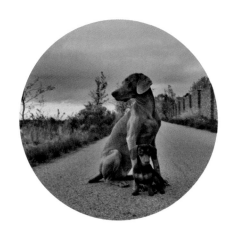

# MARCH

### Indi's First _____

By March the snow had melted and
it was finally warm enough to start
taking long walks. Indi likes going
for walks. However, a lot of things
startled her when she experienced
them for the first time.

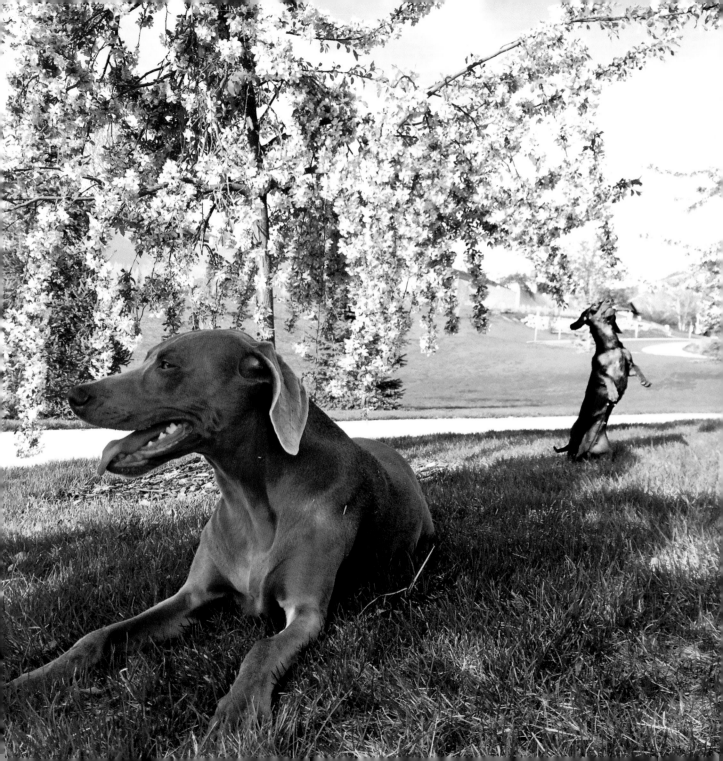

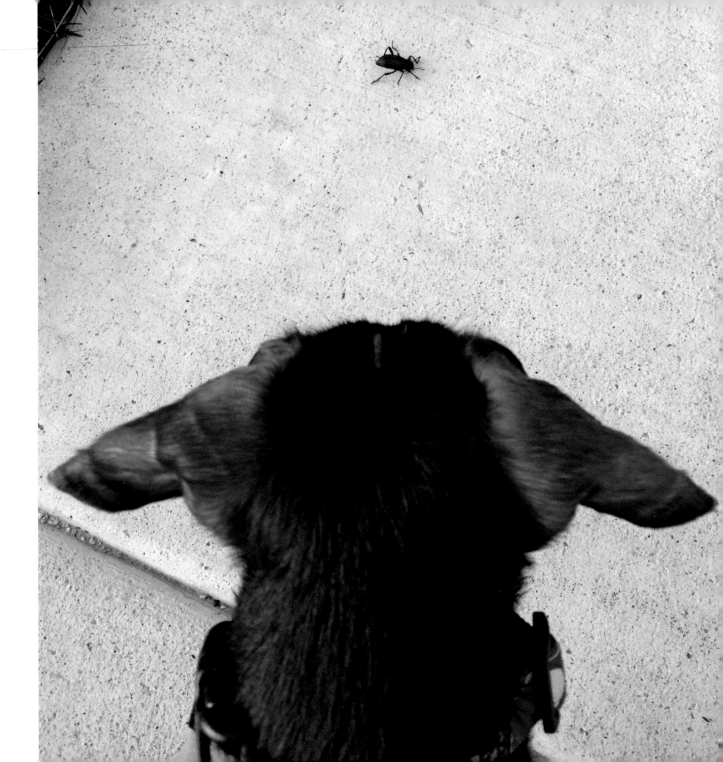

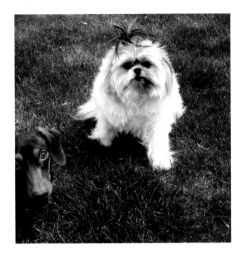

Skateboarders. "Those took me a long time to get used to also. I still don't quite understand," I explained to her as one rolled by us.

Bugs. Indi's first encounter with a beetle was memorable. "Leave him alone, Indi. He is probably more scared of you than you are of him," I warned.

The Olsen Twins. (Not to be confused with the celebrities.)

The Olsen Twins are two little dogs with fluffy white hair. They often wear matching pink sweaters and have matching pink leashes. The first time Indi saw one of them, she couldn't stop staring.

"Stop staring, Indi. It's rude," I whispered to her as we walked by them.

"But it has a ponytail on top of its head!" she exclaimed.

# APRIL

## Happy Campers

Sage and I never went on an actual vacation together. We spent a few weeks each year on holiday at our grandmothers' houses but that was it.

Sage was kind of a homebody. She got sick if she was in the car for too long and she vowed never to set foot on an airplane.

"I once saw a show where there was a Gremlin riding around on an airplane wing during a rainstorm," she explained.

One of the best memories I have with Sage was the night we went camping in the living room.

Outside, the world's most horrific snowstorm was taking place.

"Ladies, we aren't going anywhere!" Papa announced as he began to gather up every single blanket in the house. He and my mother spent the next hour building the most charming fort for me and Sage. Oh, the things these people would do to entertain us!

We spent the entire evening in our fort. It was heaven on earth.

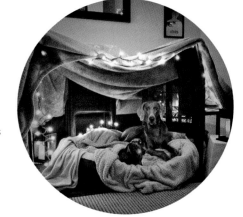

When it was time to go upstairs to bed, Sage wouldn't get out of the fort. And the two of us slept there every night for the next week.

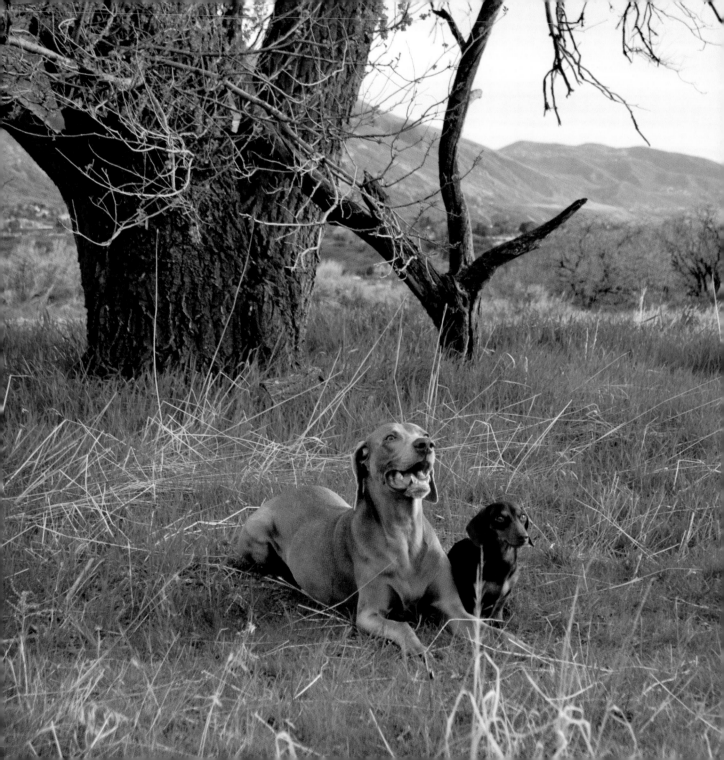

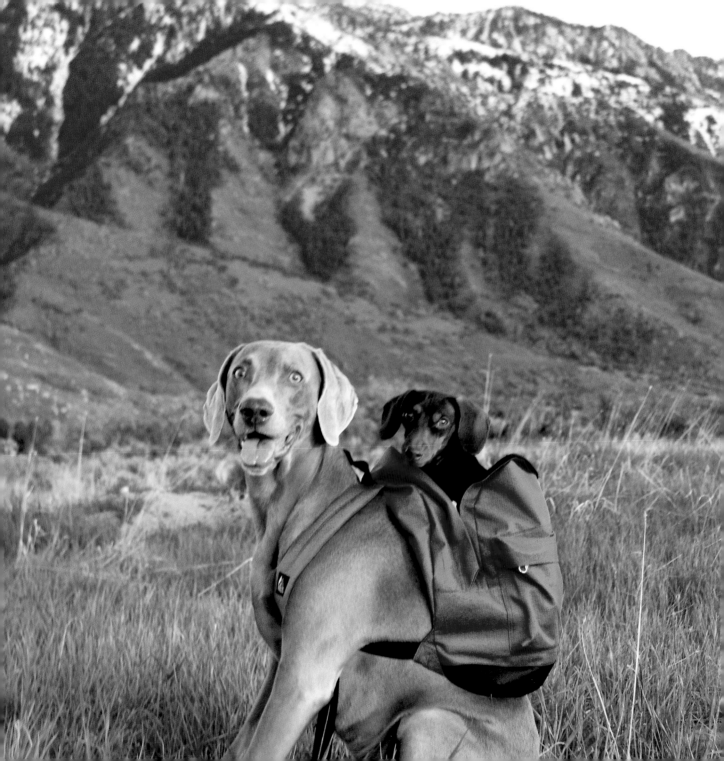

Indiana wasn't too impressed with the fort when my parents tried to re-create this magical moment for her and I.

Papa draped a sheet over a chair, and Indi took it down with her paws.

"We should take them camping for real," my mother said.

"Like outside?" Papa asked.

"YES PLEASE!" I yelled.

"You are going to get in trouble for barking in the house," Indi whispered.

"Harlow! No barking in the house!" my mother warned.

"So predictable," Indi snickered.

That weekend my parents loaded the family station wagon and we set out on our very first camping trip!

"Are we there yet?" Indi asked every ten minutes.

There really is nothing like the great outdoors. There are unlimited things to chew on. There are so many things to look at. So much to explore!

Taking Indiana into the mountains for the first time was interesting. She hadn't quite learned that wandering off on her own was not appropriate. She would see a bug or smell something new, and the next thing I knew she would be a mile away. "What are you thinking, Indi!? Someone could steal you! Stay close by."

"But I think I just saw Kevin!" she shrieked. (Kevin was Indi's toy squirrel.)

"I don't think so, Indi. You didn't bring Kevin."

"No, but I saw him. He saw me too. And then he ran the other way. I didn't know he could run!" she explained.

"Indi!" I told her. "I think you just saw your first real squirrel. Congratulations, little one."

The fun came to a halt when Indi stepped on a sticker bush. That was when the whining began.

"I want to go home!" she wailed. "I might need a new leg!"

"Stop being such a baby, Indi," I told her. "Look at how amazing these views are!"

Papa and I took turns carrying Indi around for the rest of the day.

We slept in a real tent that night. Outside. Under the stars. Crickets chirping. Wolves howling. It was straight out of a movie!

And then Indiana had an accident in the tent and we had to pack up and go home.

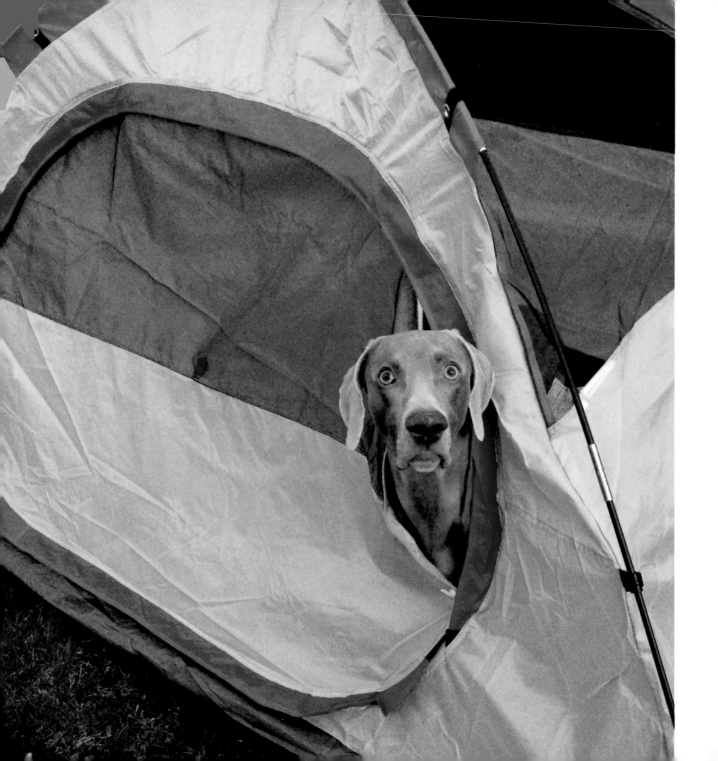

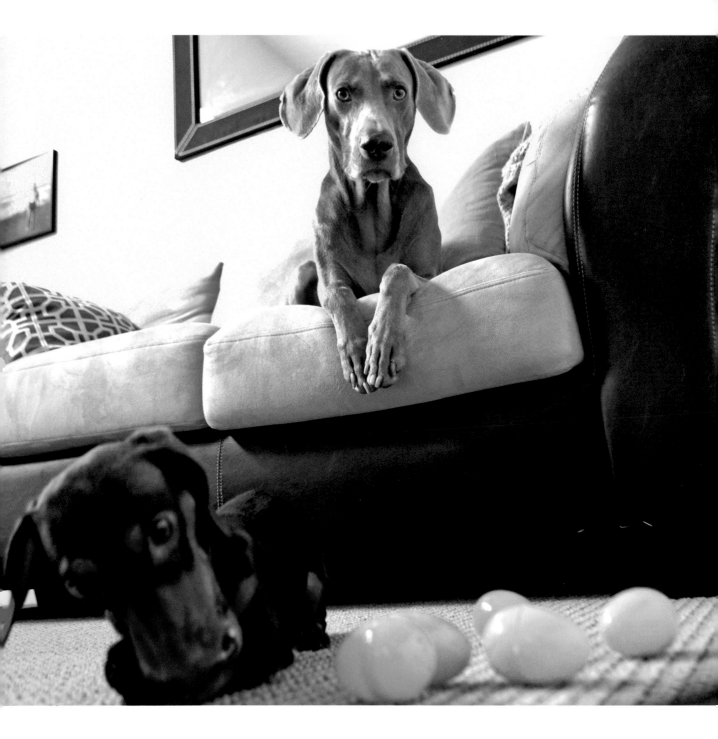

# EGG-CELLENT

On Easter Sunday my mother did the strangest thing. She put my treats in plastic eggs and hid them all around the living room.

"Go find your treats, Harlow! It's a game!" she said with joy. Okay. This was new.

"Come on, Harlow!" Indi shrieked. "It's fun!" She had already collected four of the plastic eggs.

Now, hear me out. I like games. They are a nice way to pass the time. But I do not like searching for my food, especially treats. I am not a scavenger dog.

"I am not playing," I told Indi as I sat down on my mother's feet. Just give me my treats, lady! I thought.

"More for me, then!" Indi laughed. She was having the time of her life.

"Oh, Harlow! Don't be such a fun sponge. Go play!" Papa said.

I looked away from him and stared at the wall, watching Indi out of the corner of my eye. She had a huge pile of plastic eggs now.

Fine.

I got up and went to every corner of the room, collecting eggs. They weren't hidden very well. You could smell those suckers a mile away. One by one, I began to drop the eggs in my mother's lap. When I was done, my pile was much larger than Indi's.

"You could at least act like you are enjoying this, Harlow," my mother said, opening the eggs to release my treats.

## CAR RIDES

My favorite thing in the whole world is going for a ride in the car. I know when it is about to happen. I can read my parents like an open book.

I watch my mother put on her shoes. Zip up her sweater. Pick up her car keys. And then I listen for it: "Do you want to go buh-bye?!"

You bet I do!

Windows down. Sunroof open. Tunes cranked. Rain or shine, I love car rides!

Let me tell you something that I promised my parents I would never repeat. It is one of those parenting mistake stories—the kind that all parents have. Or so I think.

Once when I was just a little pup, I was riding in the car with my head out the backseat window. My mother was driving and she had her window down too. (Her head was not hanging out the window for some reason.)

Wind in my face, I was having the time of my life!

And then suddenly I could feel it. MY HEAD WAS BEING ROLLED UP IN THE WINDOW!

"Oh my gosh, honey! STOP!" Papa yelled.

My mother slammed on the brakes.

"NO! THE WINDOW!" Papa screamed.

My mother realized what she was doing just in the nick of time. She pushed all the way down on the window switch so that I could free myself.

Alert the authorities! I thought. These humans are trying to kill me! We pulled off to the side of the road and my parents took me out of the car.

"I thought I was rolling up *my* window," my mother said frantically.

"You have to be more careful!" Papa said as he inspected my neck. And then my mother started to cry. And Papa felt bad for yelling at her.

"I am so sorry, Harlow," she repeated over and over again.

So I gave my mother a big, wet smooch on her face. "I forgive you, girlfriend," I whispered to her. But she didn't understand.

Sometimes I wish humans and dogs spoke the same language. (Please don't call protective services on my mother. I promise it was a one-time deal and she uses more caution now.)

# MAY

## Dreams

I wake up. It seems like a normal day. My parents have already left for work. Indi is entertaining herself by unrolling a ball of yarn in the hallway. I walk down the stairs to the kitchen. I pass by the living room. And then I hear it.

"Help us, Harlow! Help us! Come let us out!"

I stand there. Scared. Barkless. The noise is coming from the toy chest. Slowly I walk toward it. And I peek inside.

"Let us out! Help us! We want to play!" the stuffed animals in the box say.

"HARLOW! HARLOW! WAKE UP!" Indi shouts. I wake up to Indiana biting my ears.

"I think you were having a nightmare!" she says. "You were whimpering. Your paws were twitching. Are you okay?"

I run downstairs to the toy box. Nothing. The babies are all in their usual, lifeless state.

"Harlow, are you okay?" Indi asks again from behind me.

"I was dreaming that the babies were alive. They were talking to me. It was awful."

"You are crazy, Harlow!"

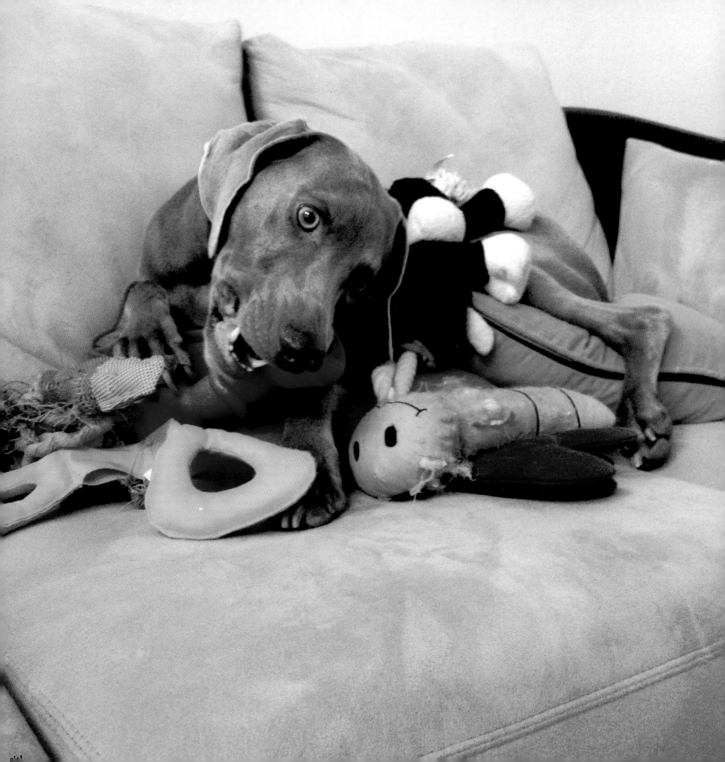

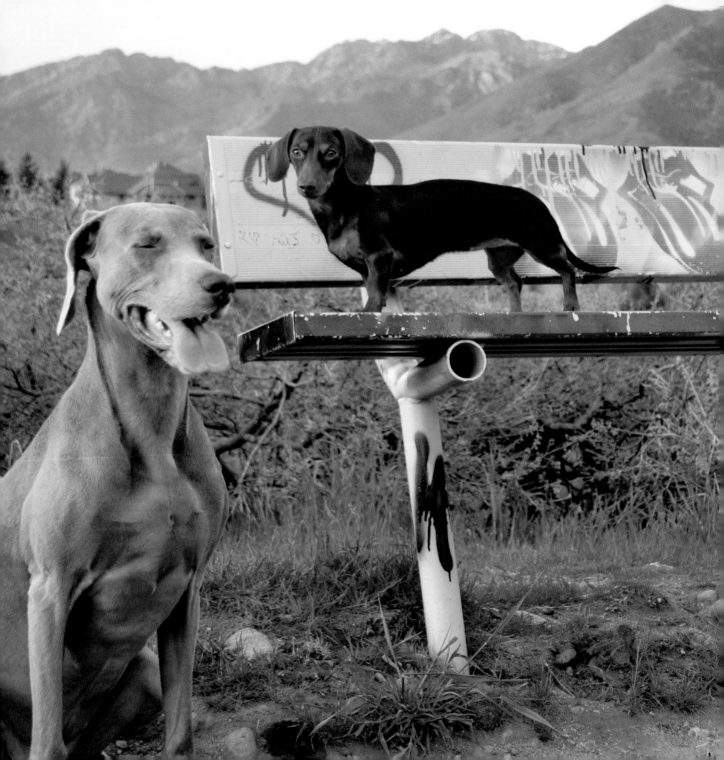

# HARLOW AND INDIANA

Indiana was growing in the strangest way. She was obviously not going to be a tall Dachshund like me, because instead of growing vertically, she was growing horizontally . . . very horizontally.

Indi was starting to get real long. I never noticed this with Sage. Perhaps because Sage was a little husky and she had a tendency to carry her length all over the place. "I am just big-boned," she would say when my mother would give her fewer treats and tell my father that they needed to watch Sage's waistline. (Although I'll tell you, once I spent the whole day staring at Sage's waistline and nothing happened.)

Indi was exactly the opposite. She was long and skinny like a hot dog. No wonder they call us wiener dogs!

Not only did Indi's body make a transformation, so did her personality. She no longer asked ten million questions per day. She pawed at the front door when she needed to do her business. She stopped waking up before the sun and started sleeping in.

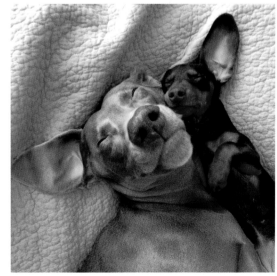

I'll be the first to admit that, in the beginning, I may have only liked Indi because I didn't have a choice. She was my little sister and I was stuck with her.

However, Indi had grown into a pretty cool cat dog and she wasn't just my baby sister anymore. She was my best friend.

She filled the empty spot that Sage once filled so perfectly.

Sometimes Indi and I complete each other's sentences.

"Hall and Oates were amazing," my mother was telling Papa one day. "But the greatest duo of all time is . . ."

"Simon and Garfunkel!" Indi and I both yelled at the exact same moment.

"Quit your barking, girls!" my mother said.

"What if they could actually understand what we are saying?" Papa asked, and they both laughed.

If they only knew.

Sometimes Indi reads my mind.

"What is the name of that movie with the doctor and the car and the clock tower where the . . ."

*"Back to the Future!"* she replied before I could finish my question.

Indi's knowledge of pop culture is impeccable! I don't know where it comes from!

Sometimes she bickers with me. We share the same opinion on most topics, but sometimes I could swear she disagrees just to get under my fur.

"Oh, Harlow, get over yourself," she says when I get upset.

I hate when she says that. "I AM NOT UNDER MYSELF!"

And she just laughs.

"STOP MOCKING ME, INDI!"

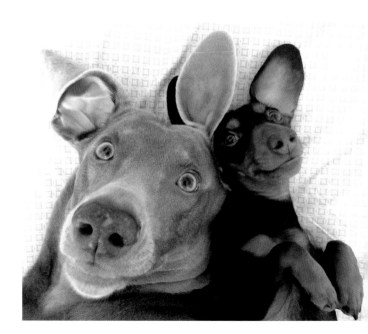

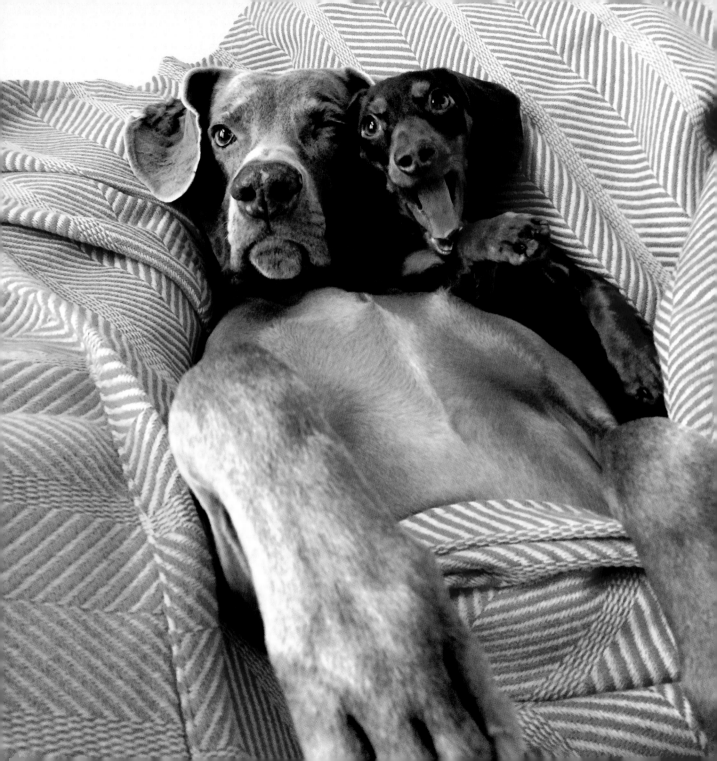

Sometimes we play practical jokes on each other.

One night I walked downstairs to the kitchen to get a drink of water. It was dark and I could barely see where I was going. After I got my drink, I went back upstairs.

"BOO!" Indi yelled the moment my paws hit the top step.

"F&t*$@%, INDI!" I had never been so frightened in my entire life. Indi laughed so hard that she cried.

Now every time I walk into a dark room, I check to make sure she isn't there. Lurking. Waiting to scare me.

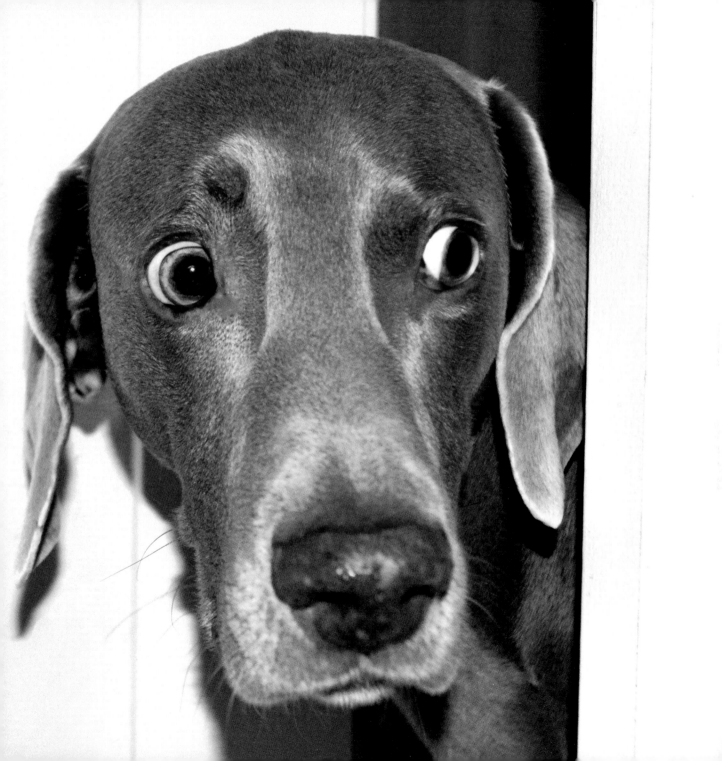

## BEST FRIENDS

"What was Sage like?" Indi asked quietly one day while we were lying on the couch.

She had never asked this question before. I think she knew that it would make me sad.

I *was* still sad. But not like before.

In the beginning, after Sage had gone away, I would go and lie down in her bed because it smelled like her.

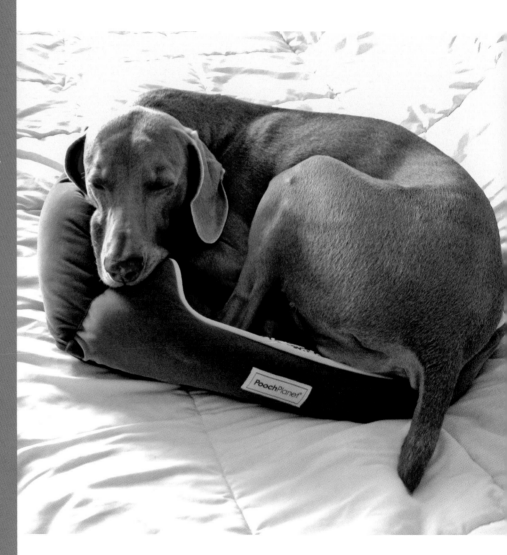

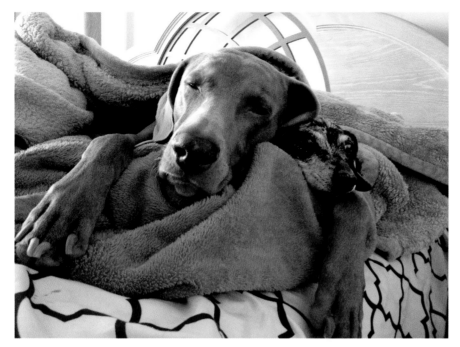

I left all her toys alone because I didn't want to ruin them. Sometimes I could swear that I heard her little nails tapping on the wood floor in our bedroom, and I would run upstairs and smell all around the room but I would never find her.

Now when I think about Sage, it is usually because I wonder what she is doing. Where she is. If she is thinking about me. If she can see me even though I can't see her. (Kind of like how I can understand my parents but they can't understand me.)

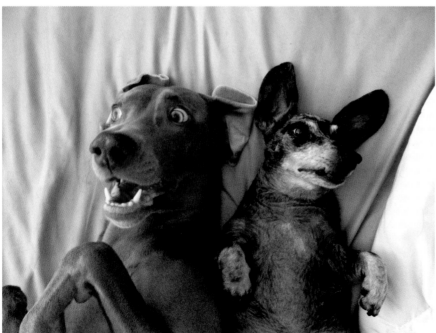

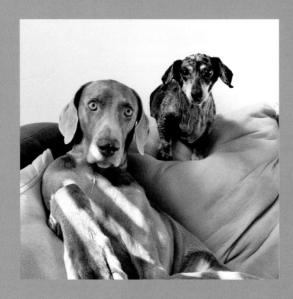

"Sage was one of the greatest friends I ever had," I told Indi.

"Do you think she would have liked me?" Indi asked.

I thought about that for a minute before I responded. Indi and Sage were alike in every way possible. Always happy. Always stubborn. Always ready for a cuddle.

"I think she would have liked you very much, Indi," I said.

"I think I would have liked her very much too."

I pictured the two of them meeting. They would have loved each other.

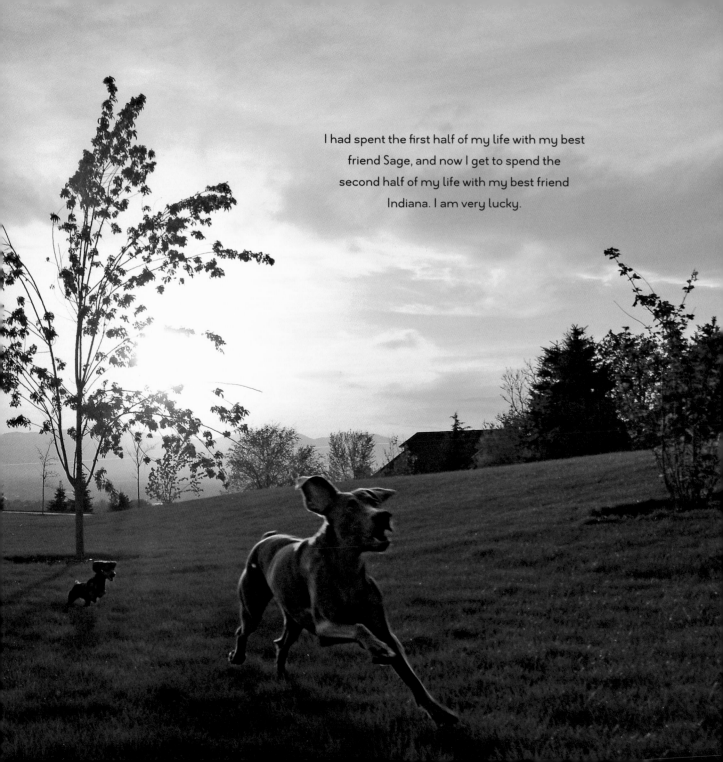

I had spent the first half of my life with my best friend Sage, and now I get to spend the second half of my life with my best friend Indiana. I am very lucky.

And that is it. The middle of our story. The rest hasn't been lived yet. We will be back when we have more adventures to share.

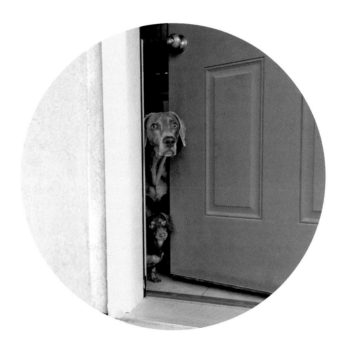

Until then, good-bye!

## ACKNOWLEDGMENTS

If you don't know this already, Jeff and I like our dogs . . . a lot! We adore them. We are head over heels in love with them! Sage, Harlow, and Indiana are the most special creatures we have ever known, and we feel blessed for the privilege we have to share their pictures, story, and love for one another in this book.

Thank you Sage, Harlow, and Indiana for letting us be your roommates/parents. Thank you for making us laugh. Thank you for chewing up our shoes. And most importantly, thank you for making our hearts feel so full every single day.

This book would not have been possible without the following three people:

The biggest dog lover of all time, Dan Toffey.

The greatest agent, mentor, and friend, Rachel Vogel.

The most amazing editor on planet Earth, Kerri Kolen.

From the bottom of our hearts, thank you for giving us the opportunity to share our dogs with the world. (Hopefully you will accept Harlow-Hugs as a form of payment!) We will never be able to thank the three of you enough.

Sofie Brooks and all of the brilliant individuals at Waxman Leavell and Putnam, thank you for all the time you have spent making this book come to life.

To our family and friends: Thank you for loving Sage, Harlow, and Indiana as much as we do, and thank you for taking such good care of them when they are in your hands . . . or paws. (Sage, Harlow, and Indiana really do have the best grandparents!)

A very special thanks to the entire community at Instagram—this is a community that has changed our lives forever and that we feel honored to be part of.

Last but certainly not least, thank you to all of Harlow, Sage, and Indiana's followers, fans, and friends. We hope that you are having as much fun as we are.

Thank you for coming on this journey with us and for all of your support.